WATERCOLORISTS AT WORK

WATERCOLORISTS AT WORK

BY SUSAN E. MEYER AND NORMAN KENT

WATSON-GUPTILL PUBLICATIONS/NEW YORK

PITMAN PUBLISHING/LONDON

Published 1972 in the United States and Canada by Watson-Guptill Publications,
a division of Billboard Publications, Inc.,
1515 Broadway, New York, N.Y. 10036

Published 1973 in Great Britain by Sir Isaac Pitman & Sons Ltd.,
39 Parker Street, Kingsway, London WC2B 5PB

Library of Congress Cataloging in Publication Data
Meyer, Susan E. (1940-)
 Watercolorists at work.

 1. Water-color painting—Technique. I. Kent,
Norman (1903-1972), joint author. II. Title.
ND2420.K4 1972 751.4′22 72-5315
ISBN 0-8230-5690-2

Manufactured in Japan

First Printing, 1972
Second Printing, 1974
Third Printing, 1976
Fourth Printing, 1978

A Note About This Book

A few years ago Norman Kent approached his friends and colleagues, inviting them to contribute to a book that would have special significance to those sharing his love for watercolor. Norman Kent's untimely passing meant that he was unable to see the book through. Having worked with Mr. Kent on an earlier book *(100 Watercolor Techniques)* and having succeeded him as Editor of *American Artist,* I felt committed to continue his efforts on *Watercolorists at Work,* and to shape it in the manner I knew he would have wanted. My sincerest thanks are due to the twenty-five artists who cooperated with me in completing the project Norman Kent had initiated.

<div style="text-align: right;">

Susan E. Meyer
New York City

</div>

Contents

Tore Asplund

It is not uncommon to find an artist who makes watercolor sketches for reference when he paints in oils. It is rare, however, to find an artist who works in the reverse. Tore Asplund prefers *oil* as a sketching medium, developing watercolors from his oil sketches. He seldom uses watercolor outdoors. In making sketches of his favorite outdoor subjects—street scenes and landscapes in America and in Europe—Tore Asplund finds it most convenient to sit in a car, sheltered from the rain, snow, or cold, and provided with the privacy he prefers when he paints. Under these conditions, he uses a 12″ x 16″ oil paintbox which he holds in his lap, placing the canvas in the cover of the box and painting with the oils almost as thin as watercolor. Under these conditions he makes as many as four or five sketches a day, even in winter. Using his oil sketches as notes, Asplund makes many small pencil sketches in the studio while deciding upon a final composition for a full-sheet watercolor.

He uses a heavy paper for painting in watercolor, preferring a 200 or 300 lb. cold-pressed, imported stock called Capri. He stretches the sheet carefully, wetting the paper in the bathtub first, then laying it on a board, and allowing it to dry just long enough to adhere slightly to the board. Then he applies a heavy tape, doubling it around the four edges to keep the sheet firmly in place. Next he places the board onto his tilt-top drawing table which is in a horizontal position at a height that enables him to paint comfortably in a standing position. He places his materials on a taboret having a white formica top, 20″ x 28″, upon which sits a 12″ x 16″ butcher's tray palette.

In an aluminum box Asplund keeps a supply of several cups filled with water so that he can clean his colors individually. His palette contains cadmium yellows—pale, medium, and deep—alizarin crimson, burnt sienna, burnt umber, cobalt blue, ultramarine blue, and Hooker's green deep, using Winsor blue and green sparingly as well. He employs only the highest quality brushes, including round sables numbers 3, 6, 8; two or three larger round sables; a watercolor mop; and two brights, numbers 4 and 8. On occasion he also finds use for a knife, sponge, erasers, and blotters.

Asplund generally starts with the sky first then moves to the center of interest. (Not all his paintings follow this approach, however; he varies the procedure if the subject calls for it.) He prefers to work on a dry surface, wetting the paper in specific areas when he wants a large wash. He may start four or five paintings before he completes one, working on each painting over several sessions. Using a trial mat or two triangles to check his composition, Asplund seldom winds up with a full-sheet watercolor. Generally he crops the composition to a smaller size.

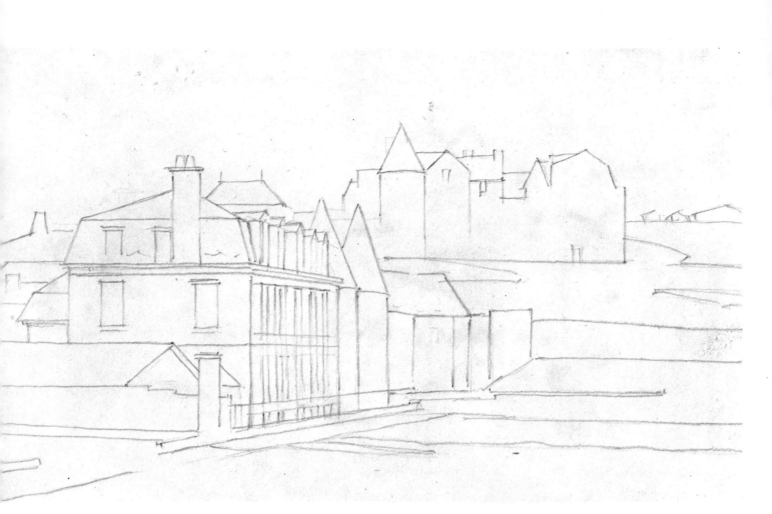

Step One: Working from a series of oil sketches made on location in France, Asplund pencils in a sketch on a 17″ x 28″ sheet of 300 lb. cold-pressed paper. Since architectural work demands some degree of accuracy, even at this early stage Asplund uses a straightedge to establish the placement and size of the windows, towers, cornices, and rooftops.

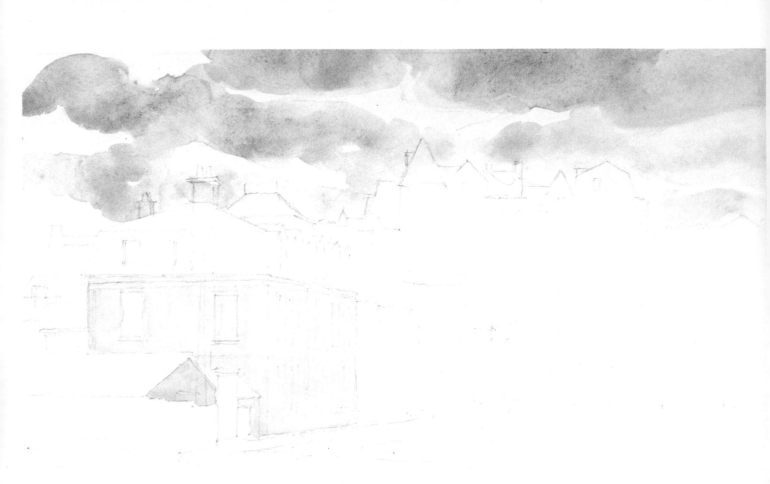

Step Two: Rather than wet the entire sheet at once, Asplund dampens the area on which he is painting section by section. He drops a highly diluted wash of blue into the wet sky area first. The pigment is heavier in some sections of the sky than in others so that the lighter passages appear to be clouds. Then he sets in the color for the main building, using cadmium yellow pale.

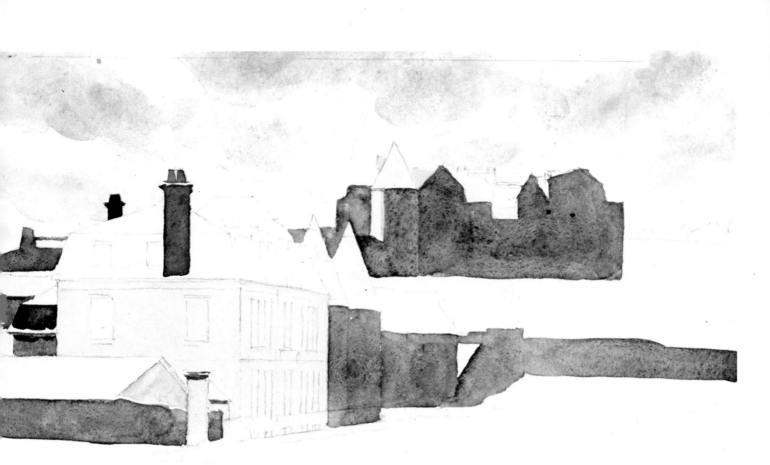

Step Three: Now Asplund moves to the darker values in the architecture. First he applies a sediment wash in the more distant structures; as the pigments mingle they give the impression of moldering walls. Then Asplund carefully paints the two chimneys, both differing in values so that greater depth is suggested. Finally, he brings the deep values to the left-hand edge of the paper by painting the stone wall and small sections of building along that edge.

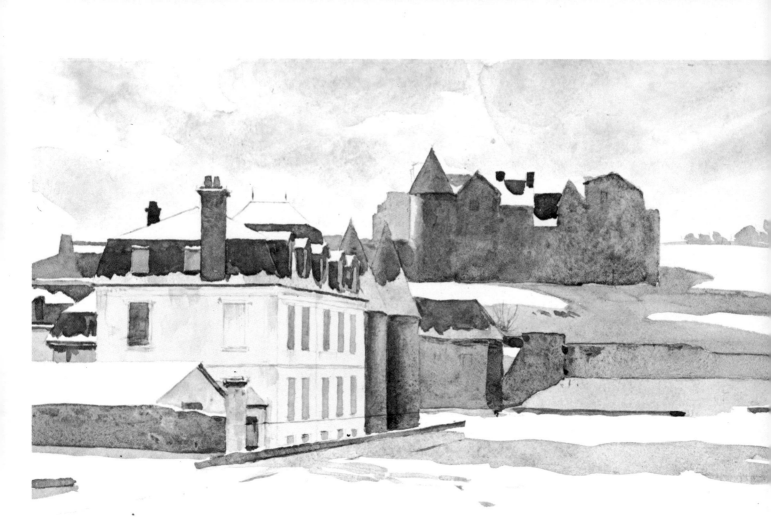

Step Four: Continuing in the same vein, Asplund now considers the rooftops and towers. As he paints he leaves certain areas free for the windows and snow. Then he indicates the shadows on the snow with a diluted cobalt blue and paints in the windows in the pale yellow building with various diluted mixtures; here they are *darker* than their surroundings.

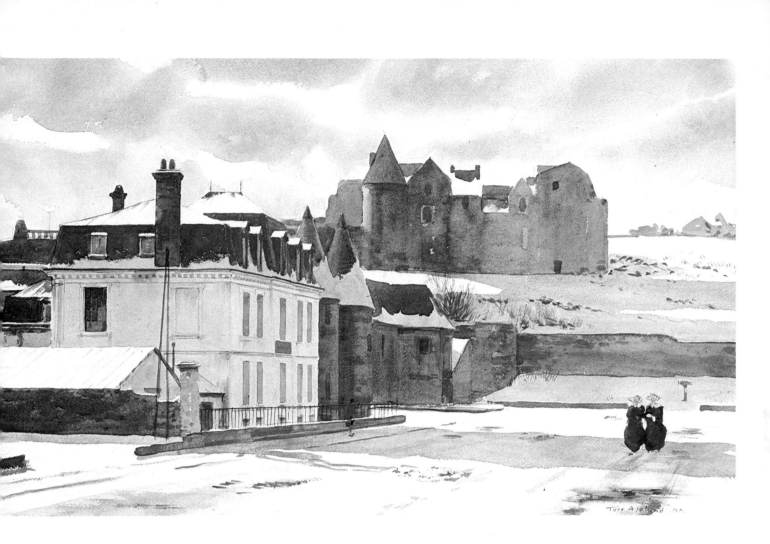

Step Five: Creil Sur Mer, Normandy, France, 17″ x 28″. Finishing details are now added. The figures are brushed in casually, the fence painted in with a number 3 sable, and textural details are indicated on the terrain. Architectural details are polished here as well: the windows, the texturing on the walls, the cornices on the building. The painting is now complete.

Ralph Avery

Ralph Avery's watercolors are distinguished by a handsome color orchestration—the result of his natural endowment, cultivated by years of study and experimentation. His palette of tube colors consists of vermilion, cadmium orange, cadmium yellow medium, lemon yellow, phthalocyanine green, phthalocyanine blue, manganese blue, cobalt blue, ultramarine blue, alizarin crimson, light red, burnt sienna, yellow ochre, raw sienna, raw umber, burnt umber, Payne's gray, ivory black, and cobalt violet.

His brushes are a combination of sables—ranging from a number 5 pointed one to a flat-edged number 9 and number 10, plus two other wider flats—and a number of flat bristle brushes in various sizes, especially suited, Avery claims, for painting on very rough paper.

Avery admits to using a variety of papers and illustration boards—including 300 lb. Arches and a number of lighter weight stocks. He says: "I like to try different surfaces so I will not get into a habit formed by using the same paper for every painting." Sometimes he selects the rigidity of a rough illustration board, and at other times, a paper stock so light in weight that he has to stretch it on a board.

This artist's other equipment is limited by choice. He uses various aids to effect changes both in wet and dry surfaces, such as a knife or razor blade, a sponge, cleansing tissue and eraser, and on occasion, rubber cement or masking fluid. For outdoor painting Avery uses a light, collapsible easel; but in the studio, where he does most of his finished painting, he prefers a large drawing table which can be used flat or easily tilted. A large side window, admitting north light, supplies his daytime illumination.

When sketching outdoors, Avery often spends considerable time selecting his motif by viewing the subject from different angles. Then, when he is satisfied with a particular position, he begins painting without resource to any preliminary "roughs." He follows no set procedure as to what section he will paint first, preferring to be guided by whatever he feels is "the need of the moment." For certain areas he saturates the paper with water; but for others, he likes to work on the dry surface.

Similarly, he adds some details when the surface of his watercolor is still moist; but for other details—especially for those he feels require a special crispness—he waits until the underlying color has dried. Under these circumstances, careful study of his paintings reveals that he does not hesitate to use opaque passages in small scale—such as the introduction of figures in a street scene.

For his work in the studio, Avery usually creates one or more sketches of his subject before he begins a final watercolor. While he says he interprets these loosely, he tries hard to preserve the design of the masses established in his rough. Often these full-sheet watercolors are worked on over several painting sessions, while in between times, Avery studies the developing painting with empty hands. Sometimes a trial mat, even a light sheet of glass and a frame, help him to decide on his next step—or no further step at all.

For an artist who is referred to as a stylist and a highly skilled technician, it is refreshing to find that he follows no one method—as the previous testimony asserts—and that the great success that has attended his work depends primarily on his sensitivity to mood and atmosphere, his conveyance of a personal expression that has *used* technique to create art.

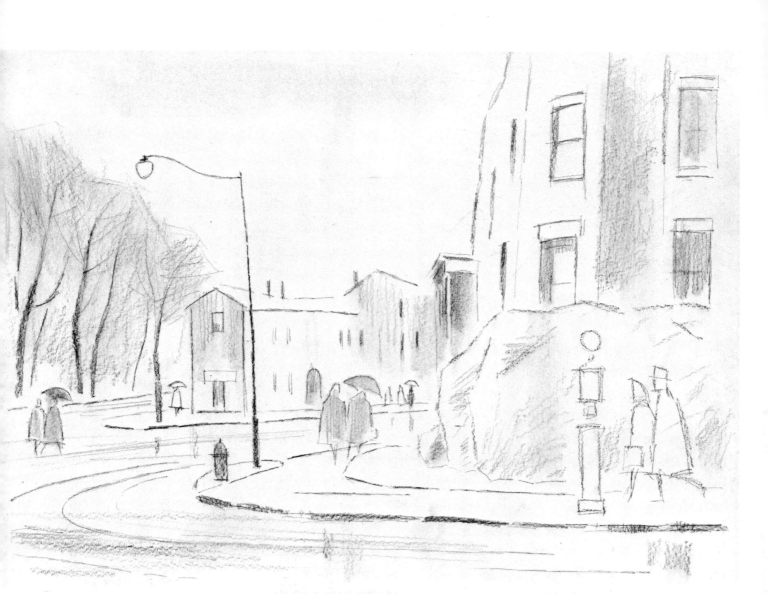

Step One: First Avery makes a rough sketch, a drawing that serves merely as a guideline to describe the major masses in the painting. He makes no attempt to draw in detail but only blocks out the major divisions of space. Then he draws in the contours on the watercolor sheet. Avery does not derive his ideas from a sketching trip. Being what he calls a "downtowner," he continually finds interesting subject matter in his own locale. He had seen this subject many times and made mental notes before he pulled his ideas together for this painting.

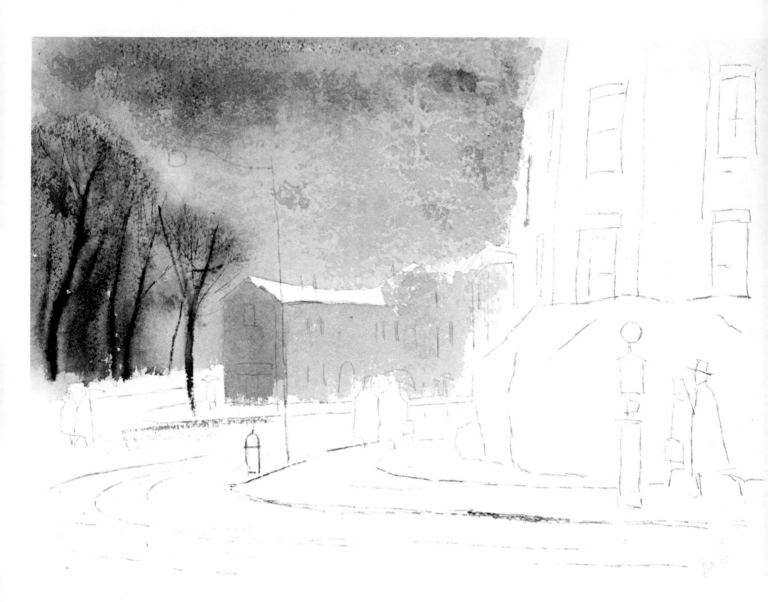

Step Two: After drawing in the principal lines on his watercolor sheet, Avery wets the paper and establishes the sky area. Although Avery knows the sky will be modified later, he wants this cool blue to determine the handling of the other areas, since the painting will depict a cloudy day. Avery drops in his paint on a wet paper, allowing the pigment to settle and break up to create the mottled quality of a turbulent sky. He swiftly indicates the trees at the left.

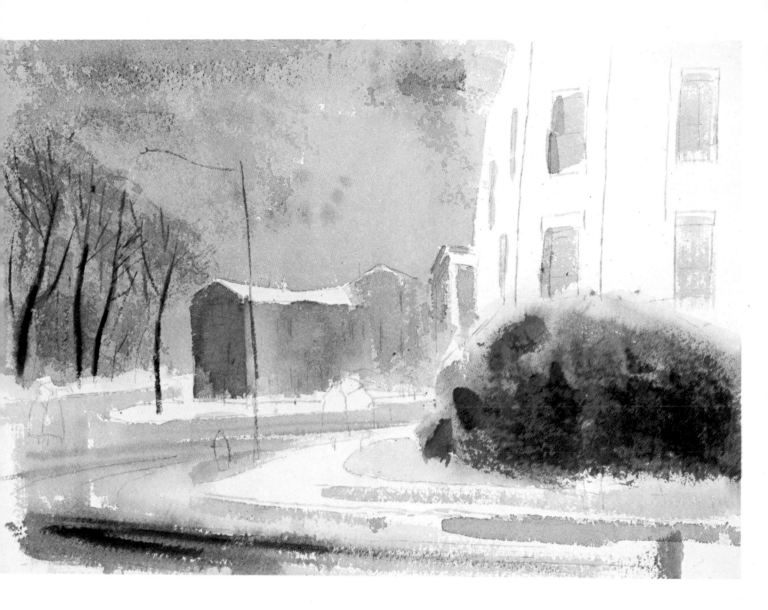

Step Three: Next Avery turns to the mass of dark green hedge at the right. At this point he establishes the values in the painting: he places the dark passage in the street at the lower left (darkest value), the reddish color in the center building (middle value), and retains the white of the paper for the lightest value. Still working on a wet paper, Avery indicates two areas of yellow where the grass will be set off from the pavement.

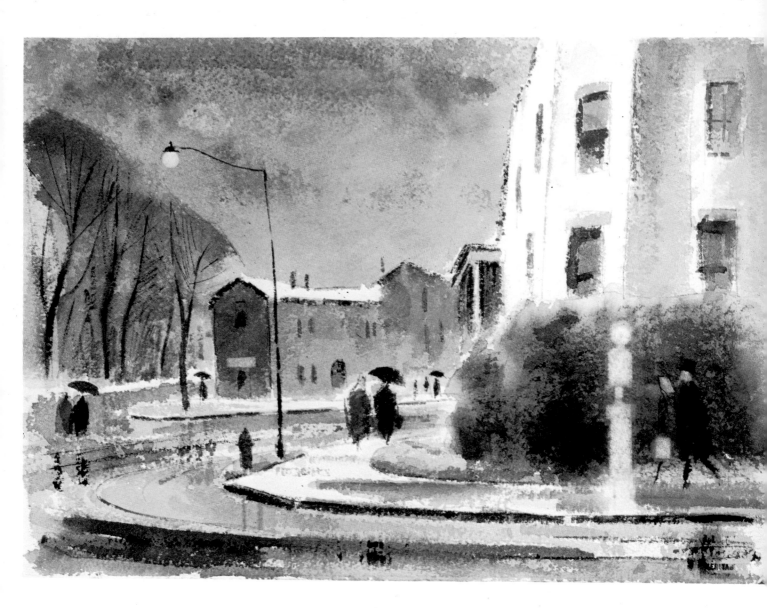

Step Four: Once the values are established, Avery is free to concentrate on the smaller details. He is now working on a damp surface. The figures are indicated; dark strips of paint define the buildings, and patterns in the street, lamp post, hydrant, and windows are all blocked in. Placing a stencil over the hedge, Avery wipes out the green pigment to make space for the fire box to be painted red. He does the same with the lamp. He also wipes out the sign over the doorway on the reddish building and sections of the figures at the right.

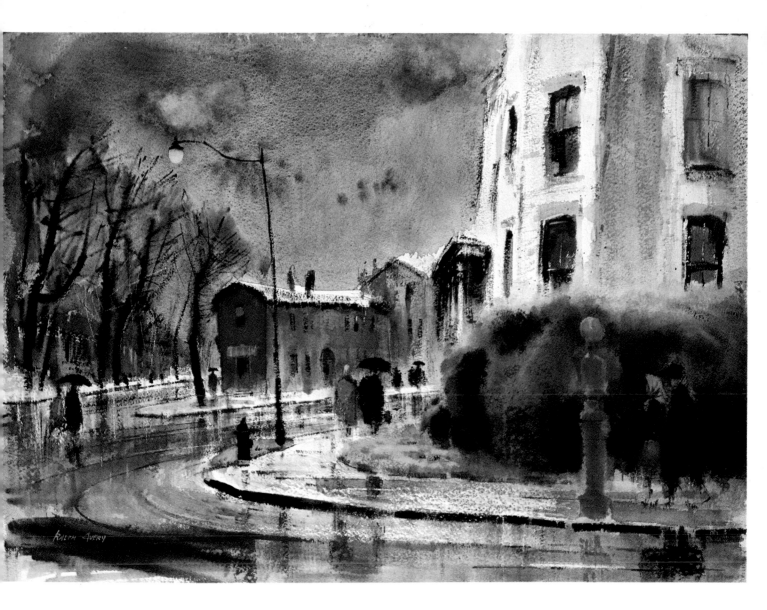

Step Five: Plymouth Circle, 22″ x 30″. Next Avery paints in the areas he had just wiped out: the fire box, the figures, and so forth. He is not concerned with sharp contours, since he can better emphasize the rainy day with soft edges. This is particularly evident in the hedges and distant trees. He completes the painting by making additional finishing touches. He makes some darks darker and picks out some areas in the reflections on the sidewalk with a razor blade to keep these areas fresh and sparkling.

Merrill A. Bailey

Merrill Bailey has painted from his car for many years. He usually carries a pocketful of tagboard cards, approximately the size of postcards, and always in the proportion of his final watercolors. On these small cards he develops his compositions. Their small size is not a hindrance but an asset: they discourage him from putting in too much; each card includes only the *essentials* of any given concept. He has managed to paint quite a few watercolors—measuring 14½″ x 26½″—in the back seat of his car, but he feels that anything larger is simply too cumbersome to handle within the cramped quarters. He uses his on-location studies primarily for sketches to capture the essential mood and composition of the scene before him.

The initial sketch on his card is a vital step in his painting procedure. Bailey stops the car only when he finds a scene that thrills him, a fleeting incident of light or color, perhaps. In his "postcard sketch" he captures the essence of that feeling, the sensation of being there. This is actually the key to Merrill Bailey's painting: his personal vision, a fleeting moment captured at just the right time.

Merrill Bailey never uses an easel, either indoors or outdoors. He normally paints on a 140 or 300 lb. cold-pressed paper. He always stretches the 140 lb. sheet (unless he happens to be using a watercolor block), but when using a 300 lb. paper, he simply tapes it down onto a board without stretching it. In the summer Bailey is partial to Arches because it retains a wash for a longer period of time than other papers. In the winter, he uses J. Green Crisbrook in addition to Arches, since his favorite sheet is no longer available, 140 lb. cold-pressed Whatman.

Bailey's palette of tube watercolors includes burnt sienna, burnt umber, Van Dyck brown, Payne's gray, ivory black, yellow ochre, cadmium yellow medium, cadmium lemon, cadmium orange, cadmium red light and medium, alizarin crimson, phthalocyanine blue and green, and Hooker's green dark.

For brushes, Bailey prefers Winsor & Newton red sable rounds in numbers 4, 8, 10, 14. He seldom uses flats, except for carrying clear water to areas he intends to work wet-in-wet, in which case he selects a 1″ to 2″ flat. Bailey also uses a large squirrel hair sky brush for laying in subtle washes, a soft brush he feels is vital for this purpose. For picking up or lightening areas that are too dark, he uses oil bristle brushes and old scrubbing brushes for textural effects. (Bailey has grown to respect the usefulness of old brushes!) Although he *will* resort to the razor blade and sponge for specific effects, he no longer considers rubber cement for masking because he dislikes the hard and uncompromising edges the cement leaves when removed.

If the sky plays an important role in the composition, Bailey paints it first, working from the horizon back to the foreground as a general procedure, with a flexible plan developing as he moves from the middle distance and approaches the foreground. He finds it unwise to plan things of a dark nature in the foreground too early, and instead he simply visualizes them in his mind but actually does not place them until later in the development of his watercolor. In this way he prevents "spots" of color from dominating, and the areas in his paintings emerge in harmony. The application of the paint is equally important: Bailey feels strongly that there should be a delicate balance between wet-in-wet—which gives softness—and the use of hard edges placed only where they count.

Bailey does not feel that it is imperative to finish a watercolor all at once. Occasionally this may happen, but generally it does not. He normally finds it necessary to return to a painting for completion. He has even finished a watercolor years after it was begun.

Bailey uses a trial mat as he proceeds, carrying one with him even when he works on location.

Step One: Merrill Bailey estimates that he has about two hundred postcard-size sketches in his file, pencil sketches he has made on location. For every one of his watercolors he uses one or more of these sketches for reference. This painting is based on a sketch of an old willow. The broken tree presented problems in the composition, so Bailey enlarges the sky area in his painting, a means of giving relief to the complex maze of branches that are present in his sketch. To begin his watercolor, Bailey first makes a contour drawing in pencil on the sheet. Over this he applies a warm, flat wash in the upper section of the painting.

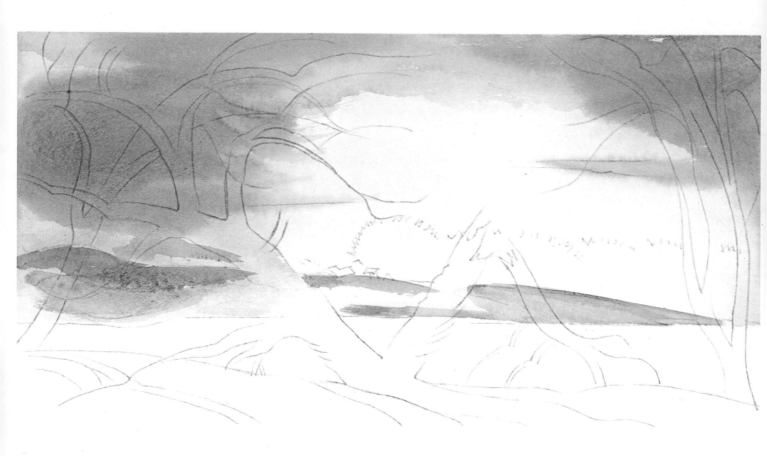

Step Two: While the pale yellow wash is still wet, Bailey drops in blue and red pigments in the sky area, retaining the warmth at the same time. Next he brushes in the distant hills in ribbons across the page. As the second wash settles into the first, the pigments mingle and break up, creating textures in their puddles.

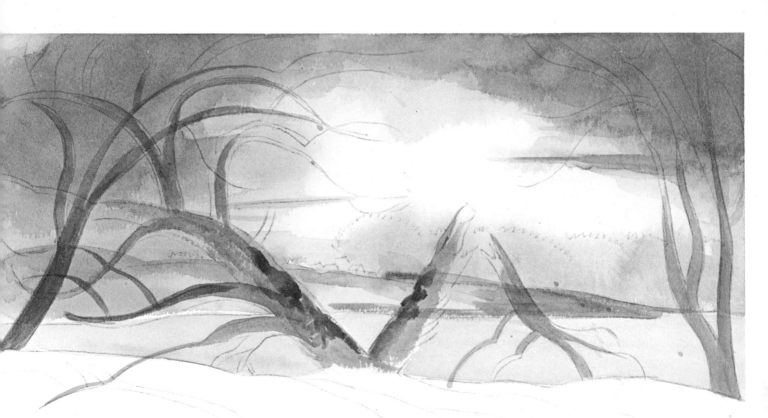

Step Three: Before the sky wash dries completely, Bailey develops this area further. Additional blues strengthen the sky and by leaving the warm yellow area of his first wash, he suggests the winter sunlight emerging in the distance. Next Bailey drops in a slight suggestion of the trees along the horizon. As the paper becomes drier, he indicates the branches of the foreground trees with sweeping strokes to give movement. Texture is added with burnt sienna along the trunk of the foreground willow tree.

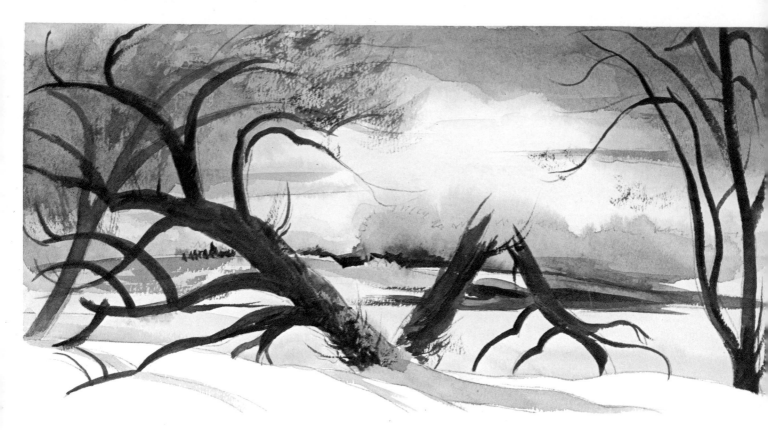

Step Four: Now Bailey places some of the darkest values and establishes the key of the painting with the more colorful accents. The sheet has dried and he can enrich the surface with heavier applications of pigment. The underwashes have established the tonality of the painting, and Bailey strengthens the shape of the trees, the horizon, and the shadows along the snow. Finally, with a drybrush technique, he indicates the brush of foliage on the trees.

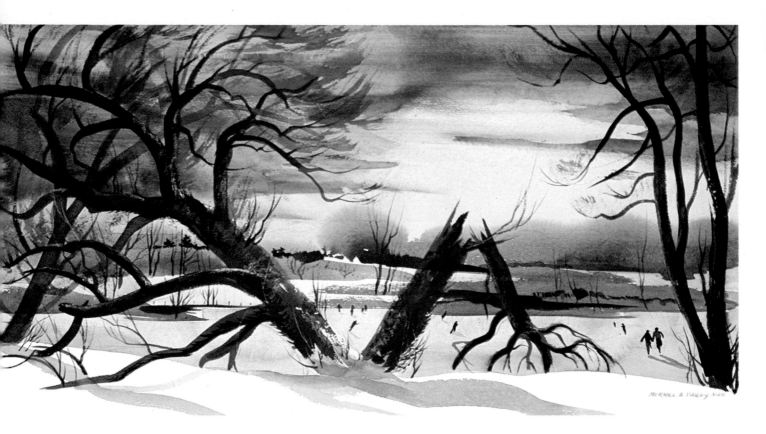

Step Five: Skating, 14″ x 26″. In the final stage, after the surface is dry, Bailey tightens the details: the foliage is extended and the elements on the horizon emphasized. With a number 3 red sable he draws in the feathery trees in the distance, the fine branches in the foreground, and the skaters on the pond with their delicate shadows. These skaters add both scale and movement to the painting.

Robert Blair

Back in 1938 Bob Blair was already experimenting with certain methods of action painting, which became popular among artists years later. His procedure, even then, was characterized by extremely free methods of painting, generally on a large scale with large tools. His paintings often developed out of swirling blots of color on wet paper. Yet at the same time he was also painting detailed studies of nature, and he emphasized the importance of drawing to his students, even while teaching the extremely free techniques described above. He would demonstrate painting with a 3″ or 4″ lacquer brush (the 1″ sable and ox hair brushes available at that time were too slow for covering large papers).

To meet his varied demands, Bob Blair uses an extensive palette of tube watercolors: Indian red, ultramarine blue, cerulean blue, cobalt blue, Prussian blue, manganese blue, yellow ochre, cadmium red medium and light, cadmium yellow, cadmium orange, ivory black, English red, burnt umber, burnt sienna, permanent green, raw sienna, oxide of chromium, and acra red. Occasionally he also uses manganese violet, ultramarine red, Mars violet, lamp black, Payne's gray, India ink, Venetian red, golden ochre, Mars black, phthalocyanine green, madder lake, alizarin, green earth, Chinese and titanium white (usually on toned paper), and black Chinese ink sticks (used like crayon on wet paper).

The tools Blair uses for applying his paints range from the traditional to the highly unorthodox, extremes altogether characteristic of this unusual artist. His brushes include 2½″ to 4″ camel's hair lacquer brushes; numbers 3 to 8 sables; ½″ square oil sable, ½″ ox hair; 1″ ox hair; foam rubber brushes, 1″ to 4″; fan brush; and housepainter's brushes up to 12″. Additional brushes are homemade, some from fur, others from cigarette filters glued together. This is not the end of his assortment of applicators. Indeed, he will also use his fingernails; kleenex; rubber squeegees, 8″ and 1″ long with foam rubber sponge; a 6″ sheep's wool shoe brush; palette knives; cooking spatulas; knife with point; razor blades; blotters; newspapers; squirt-top bottles; fur caps; sandpaper; weeds and twigs; and insect sprayers.

Blair uses an equally wide assortment of papers, ranging from cold-pressed and hot-pressed 72 lb. sheets measuring 30″ x 22″, to rough 300 lb. sheets, and large heavy rolls of 100% rag paper 43″ wide.

If Blair decides to stretch his paper, he wets both sides and applies the sheet to a non-absorbent, smooth board. When he intends to work dry, he applies masking tape to two or four edges of the sheet, rather than stretch the paper. Or, he may actually prefer a wavy sheet for certain effects, in which case he will wet only one side of the paper and lay down the sheet, exploiting the qualities of a buckled paper in his treatment.

If Blair happens to be working from a sketch, which he does occasionally, he interprets the drawing loosely, simplifying and improvising the ideas in his painting. Sometimes he simply draws, in pencil, geometric shapes directly on his watercolor sheet and uses these shapes as an initial point of departure for his painting.

When painting outdoors, Blair refers casually to a rough pencil sketch or works directly on the paper, but he does not draw on his paper. Normally he covers the entire surface of the paper first, beginning anywhere, working from light to dark or the reverse. He may add some detail when the sheet is still damp, jumping from one part of the paper to another, depending on the dampness of the sheet. Finally he adds details in the dry areas. In all his work he attempts to carry the painting through to completion in one sitting.

For color Blair sometimes squeezes out an entire tube of paint onto the paper, using black freely, but almost always mixed with a great deal of another color. As the color begins to flow on the sheet, he pushes it in the direction he finds desirable: "The element of risk is part of the challenge in watercolor," he maintains.

Step One: First Blair saturates his paper, a mounted, extra-heavy rough Ruysdael sheet. Colors squeezed directly from the tube are dropped onto this wet, unmarked paper. Blair allows the colors to bleed together, pushing here and there where he thinks necessary with a 3″ camel's hair brush. From the outset he intends for these colors to merge in the final painting. Although he occasionally uses this method of dropping in color to stress linear effects, here he has decided that all the linear work would be done later with large and small brushes.

Step Two: With the paper still wet, the artist develops the design by encouraging the colors—with the camel's hair brush—to move around freely. Here he allows the colors to run, merging into each other and forming patterns of color throughout the sheet. The wet paper prevents hard edges from forming so that Blair retains a soft effect.

Step Three: As the paper begins to dry, more detailed shapes appear, and a foggy landscape emerges. The line through the center of the sheet establishes the horizon. At this point Blair blends most of the colors over the entire painting. For this painting he uses Indian red, ultramarine blue, ivory black, viridian, cobalt blue, cadmium yellow, yellow ochre, oxide of chromium, permanent green, and cadmium red.

Step Four: The paper has become damp, and the clouds and foreground take on greater definition as Blair continues to work. Occasionally he adds water to areas he wants to develop further, carefully rewetting his sheet so that the water will not run into the damp areas to cause unwanted washes. With a clean brush, Blair pulls out the foreground log, knowing that he will have to repeat this procedure at a drier stage to lighten the tone still further. As the painting continues to dry, he must work faster, moving quickly back and forth and up and down all over the painting. (The damp period is usually short, and Blair does much of the drawing with brushes at this stage.)

Step Five: Passing Storm, 34″ x 46″. Collection, Mr. and Mrs. Murray Warner. While the painting is still damp, Blair again pulls out the color in the foreground log and with the back of his fingernail pulls out the branches of the log. He uses the front of his fingernail to scratch in the foreground spider web, taking care to avoid sections that are still too damp for this kind of treatment. Tonal adjustments are made here and there where the paper is still wet. Final darks (in the trees, for example) are put in directly with a mixture of ivory black and black India ink saturated with ultramarine blue. He uses a number 6 pointed sable for the last touches in the tree branches and for the "calligraphy" in the foreground at the right.

Glenn Bradshaw

As an experimental painter whose work is highly subjective, Bradshaw has developed a method of painting characterized by certain unique features. He has adapted the use of oriental papers to his own specific needs; he paints on both sides of the paper, using casein paint in a semitransparent manner, and he translates nonobjective forms into landscape-related images.

Glenn Bradshaw's varied palette of casein colors includes alizarin crimson, cadmium red light, cobalt blue, ultramarine blue, phthalocyanine blue, cadmium yellow light, Naples yellow, ivory black, lamp black, phthalocyanine green, permanent green light, raw sienna, raw umber, burnt umber, titanium white (often two different brands because each brand in casein has different properties), and cadmium orange. Over the years he has picked up nearly every color on the market, so these pigments include only the ones used regularly, although he has others available "for special occasions."

For painting he has an assortment of all kinds of brushes, both old and new. Since casein can be extremely hard on brushes, Bradshaw finds it necessary to have a wide selection: wide, flat, white-haired oriental brushes with stitched-in hair and natural wood handles in 1″, 2″, and 4″ widths; flat lettering brushes in ox hair, ¼″, ½″, 1″, and 1½″; round watercolor brushes, sables numbers 3 through 9; rough watercolor brushes in ox hair, number 12 or thereabouts, which are reduced to a center tuft of hair for a very flexible, calligraphic tool. He also uses bamboo-handled brushes, round, small, medium, and large; and an additional assortment of brushes, accumulated over twenty-five years, are also handy if needed.

For a painting support Bradshaw prefers Japanese rice papers, particularly Sekishu white (25″ x 39″) and Kozo white (25″ x 39″).

Bradshaw does not work at an easel or table. He lays his paper down on a large piece of ¼″ Masonite or plywood (usually 36″ x 48″), which is placed in a flat position on top of large boxes. Since Bradshaw's painting methods require frequent changes from one painting to another, such flexible "studio furniture" allows him to make effective use of a small and often congested studio space. (He admits that if his studio were larger he might use a more conventional means of supporting his papers.)

Bradshaw normally works directly on the paper from first concept to finished painting, without prior planning or drawing, although he may use a small ink doodle for the skeletal composition of a painting. He begins with a bold, non-objective, loose grouping of shapes, lines, and patterns in diluted paint, an initial step accomplished rapidly. The paper is then permitted to dry.

Subsequently he applies washes of color to both surfaces of the paper. Because the paint is quite fluid and the paper is thin and absorbent, paint actually stains the paper and soaks through to the other side to some extent. He exercises great care to avoid building up the paint too heavily. The paper is thin, unable to support thick paint. Bradshaw stains the paper or coats it thinly, without covering the sheet densely. The paper is allowed to dry between each application of paint. (Bradshaw keeps a number of paintings in progress simultaneously so that he can use his time efficiently. While one is drying, he can be working on another.) Wet paintings are moved around several times while drying to prevent them from sticking to the boards supporting them. This is done with great care to prevent tearing the delicately fibered paper. The freshly applied paint is often blotted with paper towels to permit underlayers of color to show through to produce texture and to create patterns of color.

Bradshaw has no preconceived idea of how his painting will emerge. He develops the images and concepts as he works, although the landscapes are nearly always the result of familiarity with the lake country of northern Wisconsin, Minnesota, and Michigan.

Step One: To begin the painting, Bradshaw places a half sheet of Sekishu Japanese paper, about 19 ½″ x 25″, flat on the rough side of a piece of hardboard. He mixes a dilute solution of cobalt blue casein in a plastic bowl. For this painting Bradshaw plans to develop a landscape based on the subject of the Lake Superior shore. Sweeping brush gestures will be important in establishing the sweeping land and water shapes. However, he makes no really specific plans and no drawing either on the paper or in a sketch form. The first application of paint is bold and direct, made with a 2″ flat oriental brush (hake). Bradshaw also adds a little blue-violet for variety. Some parts of the paper are left untouched. This intitial phase takes about three minutes.

Step Two: As the paper dries, Bradshaw moves it several times to prevent it from sticking to the board. Rice paper is thin and absorbent so that color applied to one side comes through to some extent on the other side. Bradshaw uses this absorbency to overlap his colors. Often he applies paint to both sides of the paper for some time before choosing one side as the face and the other as the back. In this painting, however, Bradshaw made his decision at the outset because he preferred to develop a shore sweep open to the right and the first gesture had established this direction. Now on the reverse side of the sheet, he brushes in shapes suggestive of land forms, loosely in white and yellow with brushes of several sizes. Then Bradshaw turns over the paper and makes some calligraphic marks with pointed brushes to further suggest the land-water subject. He then applies an orange wash to the back, covering all but the major land masses. This wash is uneven as the paint puddles in some places. (Puddling increases as the paint reduces the absorbency of the rice paper.) To prevent too heavy a build-up of paint, and to avoid exaggeration, Bradshaw blots the surface lightly with paper toweling. Before each application of paint, Bradshaw waits for the sheet to dry thoroughly.

Step Three: Bradshaw blocks in more shapes on the face of the painting with a thinned white. The sky and a band just below the hill shape are covered with a blue-green wash. Although the primary forms seem fairly well established, they are unrefined. Bradshaw then applies — to the back of the paper — a rather heavily pigmented wash of alizarin crimson to strengthen the land forms. When dry, the large rhythms appear as Bradshaw had anticipated, but the large hill shape seems too red to him and less interesting than it had been earlier. A wash of cobalt blue over the hill improves the color.

Step Four: Bradshaw was disappointed in the next stage. An orange wash is applied to the face of the paper, primarily in the sky area. It is too thin and the paper wrinkles more than he wants. Most of these wrinkles disappear when the paper dries, but a few unfortunately remain. He applies a second orange wash over the sky and a part of the lower portion of the painting. Additional drawing reinforces the shapes. A large blue arc is put in to accent the shore curve. Although satisfied with the direction the painting is now taking, Bradshaw wants to improve the color and decides to undo some of the work already accomplished. He brushes in a rather dense pale yellow wash across the entire back of the painting which soaks through the paper, and he blots away the puddles so that a regular distribution of paint in a broken pattern is evident. It is now necessary to think about which of the forms will be redefined and how they might be expanded or enriched through additional lines and shapes.

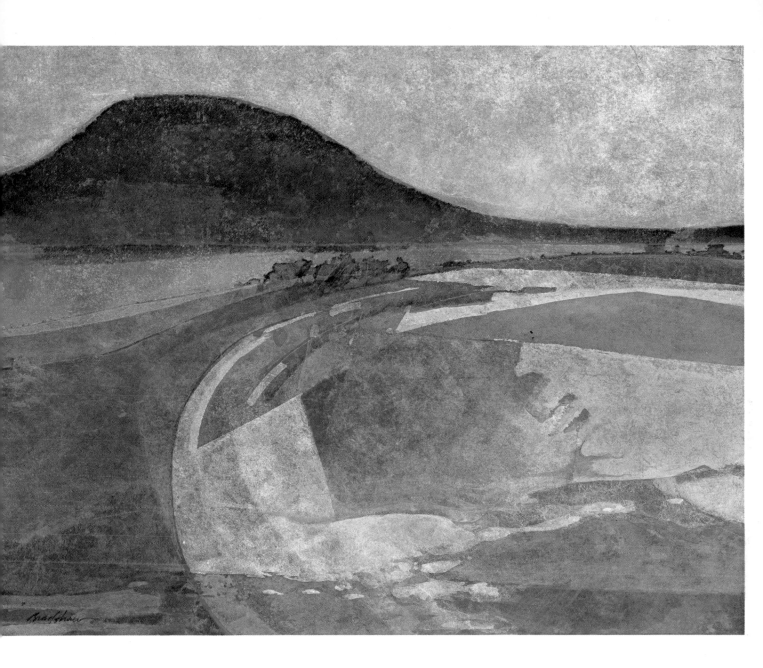

Step Five: Copper Country, 19½″ x 25″. In this last stage of development, Bradshaw works only on the front surface, primarily with thin overlays of color. Brush drawing is added sparingly for accent, change of scale, and suggestions of subject matter. The painting has progressed from the initial impromptu, intuitive, casual stage to a state in which changes and additions are made only after considerable deliberation. The paper is placed on a piece of mat board to focus attention on it and to shut out the other studio clutter for the judgments in the final stages of work. The geometric pattern is developed because Bradshaw feels it actually strengthens (by contrast) the more organic shapes and rhythms with which the painting began.

Kent Day Coes

Because of his life-long interest in railroads (particularly the era of the steam locomotives), Kent Day Coes has been particularly noted for his paintings of this subject. From his experience in this area he has developed his skills in working on location, from sketches and research materials, and works easily both on the spot and in the studio.

For his outdoor work, Coes uses Arches 140 lb. cold-pressed paper in blocks of 10″ x 14″. He carries several of these with him so that an unfinished sketch will not have to be removed from the block to make a new sheet available. Coes generally sits in the right front seat of his sedan, a practice that evolved from his interest in painting winter scenes. (Occasionally he works standing at a wooden, portable easel positioned so that the paper is flat.) He starts a broad pencil drawing with an HB pencil, then proceeds with the painting, starting with the sky and working as nearly as possible from light to dark, unless rapid changing of atmospheric conditions makes this impossible.

When he works in the studio, Coes uses Arches 200 or 300 lb. rough sheets, 22″ x 30″. (He may also use an English-made paper of the same specifications.) He stretches the paper by placing the soaking wet sheet over a lightweight drawing board, the paper held at the edges with heavy-duty package tape (two overlapping strips for each edge). Then he takes his small office-size stapler and staples through the tape onto the boards all around the edges. He seals the tape with ¼″ masking tape, with about ¹⁄₁₆″ of this taped onto the watercolor sheet itself to prevent very wet washes from creeping under the package tape. The masking tape also covers the staples.

When working in the studio from sketches, Coes usually makes a detailed enlargement, even when several sketches are combined. Changes from the original may involve an emphasis of atmospheric conditions which may have been only suggested in the sketch.

Coes rarely starts with his entire paper wet, though sometimes a very wet sky will constitute two thirds of the painted area. He often blocks out the center-of-interest detail in the darkest darks, washes over this with the intermediate values later, and then reinforces the weakened darks at the very last stage. Although details are occasionally added to a wet surface, they are generally placed on a dry one, especially when he wants to obtain textural effects. Where he tries to complete his outdoors work in one sitting (though rapidly changing conditions sometimes make this impossible), he works on a studio painting over several periods, using a trial mat to check all stages of the work as he proceeds.

Coes's palette is extensive, including cadmium yellow light and medium, yellow ochre, cadmium orange, raw and burnt sienna, cadmium red, raw and burnt umber, sepia, brown madder, alizarin, alizarin crimson, dioxazine purple, cobalt blue, Antwerp blue, phthalocyanine blue, indigo, viridian, phthalocyanine green, Payne's gray, designer's white (permanent). His brushes include a number 2 or occasionally a rigger; numbers 6, 8, 10, 14 round sables; 1″ and 1½″ flat sables; and bristles.

Coes does not hesitate to use other kinds of equipment to aid him as well: knife; razor blade; sponge; eraser (both gum and kneaded); pencils (HB or 2B if the area is to be quite dark in the finished painting); an electric hairdryer to hasten the drying time of washes; and a water spray from a plastic container intended for gardeners, an excellent tool for dampening areas when desired.

Step One: This 2B pencil drawing was enlarged from a small, full-color painting made outdoors on-the-spot. This drawing is considerably more complicated than the one made on the scene, actually just a map of the wash areas to be covered in the painting, with no attempt to suggest form or lighting. The pencil drawing is fixed with clear water, a method of removing smudges and preventing any graphite from mingling in the painting.

Step Two: A pale yellow ochre is washed over the entire painting, not a standard practice for the artist, but used in this case because of the late afternoon golden light which permeates the scene. To block out the areas which will appear as light accents in the painting, Coes uses ½″ tape, torn lengthwise down the middle into short strips, and places the torn edge on the shadow edges of his drawing. The torn edges enhance the texture of the trunks and avoid a mechanical look when the tape is removed (another reason for using short strips rather than single strips running the entire length of the tree trunk). In general, Coes works from light to dark, painting the sky and distant hill, the band of snow in deep shadow in the middle distance, the warm, preliminary modeling of the snow in the foreground. He also paints in the golden sunlit areas of foliage, a color that had been extremely intense on the spot as the sun neared the horizon.

Step Three: Proceeding with the darker values, the artist paints in the large tree
trunks in shadow on the left and the shadow side of the sunlit trees. (The sunlit
areas on the branches were too small to handle at this stage.) He paints the interme-
diate shadow tones in the foliage and develops the skeletal pattern of the small tree
trunks and dark branches. Coes deepens the shadows on the snow in the foreground,
keeping the paper slightly moist over the entire foreground area.

Step Four: Coes moves to the interior wooded area. He develops the contrast between the brightly lighted areas and the corresponding shadows, adds the deepest accents throughout, and works up to the final shadow in the foreground. Although the golden foliage seems shockingly light, this constitutes a very valuable asset to the painting as it now stands. Any portion of these areas lost from here on in will be difficult to regain. Coes drags his brush slightly to intensify the textures while allowing the moist paper to dry.

Step Five: Winter Woods, 21″ x 29″. The tape removed, the artist attacks the areas previously covered. Although they remain light accents in the painting, these areas are lightly tinted to be within the golden color relationship Coes has established. Then he puts in the lightest, sharp accents, such as the berry stalks at the left and the twigs caught by bright gleams of sunlight. Opaque mixtures are used here, light and bright as possible, and handled with very little moisture.

Ray G. Ellis

Ray Ellis is particularly taken with scenes involving subtle moods and colors—beaches, marshes, docks, and rural scenes. His selection of tube watercolors reflects his preference for subtle colors: Van Dyke brown, burnt sienna, warm sepia, raw umber, yellow ochre, alizarin crimson, cadmium red deep, cadmium yellow deep, cadmium yellow pale, Winsor blue, Payne's gray, neutral tint, olive green, sap green, and Hooker's green deep. Although he does create contrasts in his painting, he does not favor black or white pigments, preferring instead to use the white of the paper and the darkest pigments on his palette to obtain these color qualities.

For outdoor painting, Ellis uses a folding French easel which collapses into a compact carrying case and holds his brushes, paint tubes, and all necessary equipment for outdoor sketching and painting. The French easel adapts readily to any angle from flat to vertical positions. For indoor use, Ellis paints on a 50″ x 36″ counterbalanced table which can be adjusted to any angle and is easily locked into position, a table particularly useful for controlling heavy watercolor washes.

In his selection of brushes, Ellis relies on a varied assortment: number 22 round pointed sable, number 7 round pointed sable, number 2 pointed sable, number 0 sable, 3″ flat, 1″ flat sable, number 18 flat sable, ½″ flat, and ⅜″ flat. For sketching he uses a number 2 carbon pencil, 2B flat sketching pencil, or medium charcoal. To complete his assortment of tools, Ellis has an 8″ duster brush, a ruler, magnifying glass, reducing glass, fine sandpaper for scraping out, 1″ masking tape, two 9″ x 9″ fish bowls for water, four 8″ x 8″ porcelain trays for mixing colors, and a 30″ x 12″ butcher's tray. For artificially lighting his studio, he uses two fluorescent and two incandescent flexible lamps.

Ellis normally paints on Arches 300 lb. rough full sheets (30″ x 22″). He does not stretch his paper, but tapes it down on all four sides with masking tape. On occasion he also may use Arches Jumbo Elephant (41″ x 25″), 240 lb. medium surface.

First Ellis sketches in his composition very lightly and roughly on his watercolor sheet with a number 2 carbon pencil, referring to a small preliminary pencil or color sketch in which he has already determined his composition, lights and darks. If the painting includes a structure—such as a building or bridge—more detailed drawing is required for authenticity. In most of his work, Ellis begins to paint at the top of the sheet, then moves to the foreground, always working toward the center of the sheet. He lays his lightest washes first but quickly establishes certain key dark areas to give him a feeling for the completed painting. Shadows are generally placed as a last step. Ellis normally works both wet and dry, establishing a balance between the two.

When working from a sketch or color notes, Ellis allows himself the freedom of changing the composition, colors, or moving the objects in his final watercolor. On the other hand, if he has obtained just what he wants in the preliminary sketch, he transfers his drawing to the larger sheet by means of the "squaring up" method.

When the subject calls for soft edges to convey distance or mist, Ellis adds detail while the surface is damp. Most details, however, are added after all the initial washes are dry, to render the crispness necessary.

Ellis finds a trial mat an important tool for judging his composition when the painting is 90% finished. In fact, he often paints the final stages with the mat placed in position on the painting. Even for outdoor work, he carries a folded mat that he can use.

Ellis completes most of his paintings in one sitting, a session lasting from thirty minutes to four hours, depending on the size and complexity of the subject.

Step One: After selecting the desired composition from a number of pencil sketches, Ellis is ready to start his watercolor. Taking a full sheet (20½″ x 28½″) 300 lb. cold-pressed French paper, Ellis mounts the sheet on the board with 1″ masking tape. With an HB pencil, he sketches in lightly the basic areas of the painting. These are indicated very roughly for placement only, with no attempt at final delineation. Since this painting is a misty scene, Ellis is not concerned with placing a horizon line.

Step Two: Before Ellis begins to paint, he first mixes his basic washes for the sky and beach, making certain to have enough mixed for both areas so that he will not be obliged to remix during application. With a large sponge brush, he wets the entire upper half of the painting. While the sheet is still damp, he lays in the wash (a mixture of Payne's gray, Winsor blue, and olive green) with a 1½" flat brush, working right down to the beach area. Then he dips into the "beach wash" (burnt sienna, Van Dyke brown, and Payne's gray) with the same flat brush and applies this mixture to the beach area, saving spots of white paper for the pool and gull.

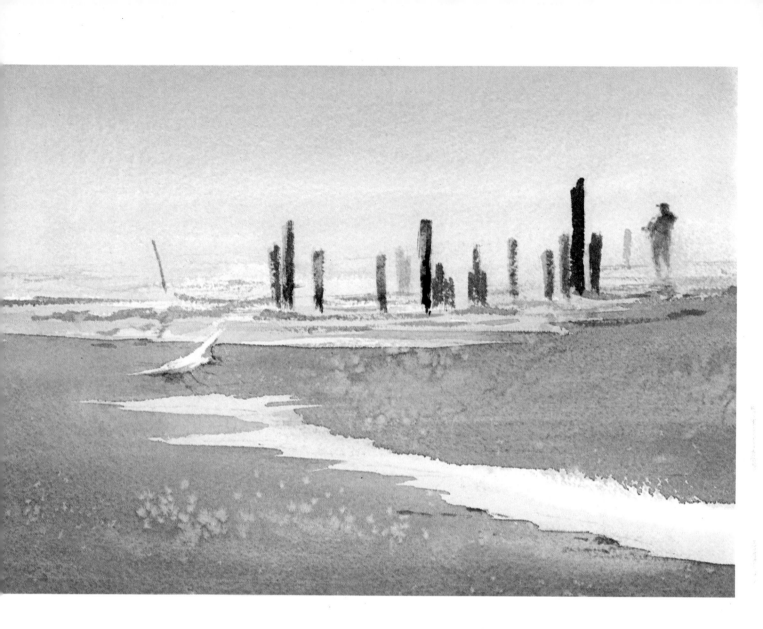

Step Three: While the first two washes are still wet, Ellis adds more pigment in areas where he wants a darker value, particularly on the beach. He strokes in some suggestion of movement in the water. Ellis then mixes several washes of sepia, Van Dyke brown, yellow ochre, and olive green for the next details. When the sky wash dries to a point where overpainting will not bleed, he starts to brush in the pilings and the figure. He varies the values here to give the sense of depth. For the pilings and figure he uses a ½″ flat sable, turning the brush to vary the width as he applies the pigment. At this stage, he just lightly suggests the shapes of the gulls. While the foreground wash is still wet, he drops in some salt to give some texture and variety to the beach.

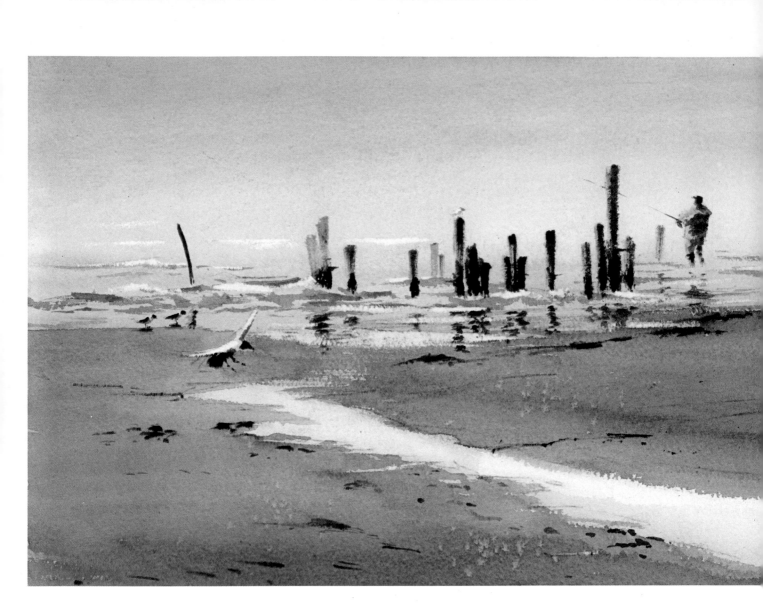

Step Four: Continuing to use mixtures of sepia, Van Dyke brown, yellow ochre, and olive green, Ellis now begins to define the pilings, figure, and gulls by using a number 7 round sable and hitting certain spots with heavier pigment. He then puts in the reflections and the dark accents on the beach. Washes of Winsor blue, olive green, and yellow ochre are mixed, and he uses these to define the waves with a number 16 round sable. Now that the sky wash is completely dry, he takes a razor blade and scrapes the sheet to lightly suggest breaking waves in the background that appear through the mist.

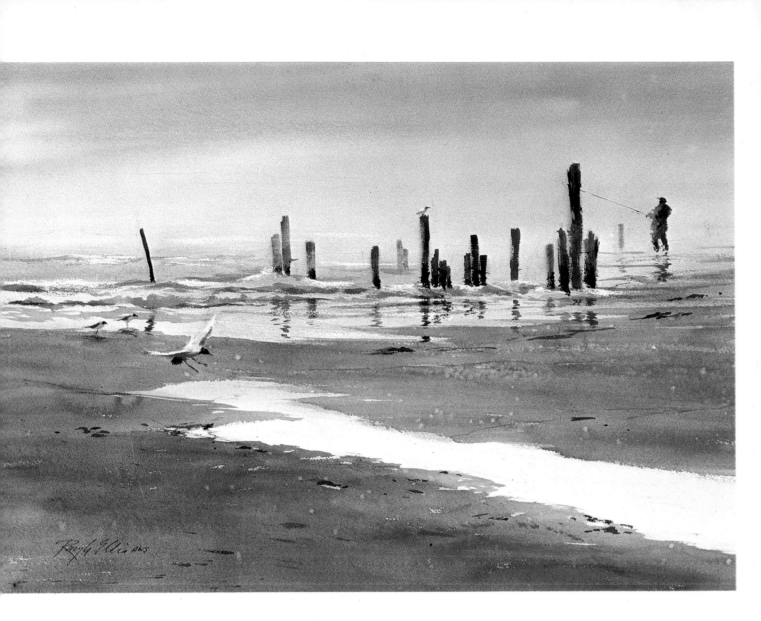

Step Five: Morning Mist, 20½″ x 28½″. At this point Ellis is ready to sharpen the details that he wants to stand out the most. For this, he uses a number 2 round sable and defines the figure and gulls. With a number 7 round sable brush dragged in a drybrush technique over the surface of the paper, he adds detail to several of the closer pilings. Because Ellis wants to capture the misty atmosphere of a New Jersey beach, he intentionally uses no opaque white pigment. The white paper provides more sparkle and luminosity than any opaque pigment could supply.

Edmond FitzGerald

Although Edmond FitzGerald generally paints with transparent pigments on a white ground, he also favors a toned paper called David Cox. This sheet is suitable for a low-keyed painting with limited light areas (which, if he needs them, are obtained by mixing Chinese white with color). The toned David Cox sheet is 140 lb.; the white paper he prefers is Arches cold-pressed, 300 lb. FitzGerald seldom stretches 300 lb. paper and will only stretch light-weight papers if they are over ⅛ imperial size. For the intermediate papers and sizes he lays down his wet sheet on a plywood board and tapes the sheet to the board with gummed tape (not masking tape, which does not adhere well to the wet sheet).

FitzGerald's palette of tube colors includes alizarin crimson, cadmium red light, Indian red, burnt sienna, yellow ochre, cadmium yellow pale, cadmium orange, viridian, ultramarine blue, cobalt blue, ivory black, and Chinese white (the last two having only limited use). He is able to accomplish the full range of his extraordinary effects with only three brushes, round sables numbers 14, 8, and 1. For his preliminary drawings vine charcoal or lead pencils (about 4H or 2B) suit his purpose. Additional equipment includes kneaded and hard rubber erasers, a pen knife, and occasionally masking liquid. In the studio, a hairdryer hastens the drying of his washes and sometimes a blotter, sponge, and facial tissues are employed for specific textural effects.

When working outdoors, FitzGerald prefers the small size format, ¼ imperial or less, and generally does not use any easel. (When he does, he uses an Anco watercolor easel, capable of horizontal tilt.) A drafting table in the studio suits his needs for watercolor painting.

As a rule, FitzGerald spends one to three hours on an outdoor quarter sheet, of which about 25% of the time is spent in developing the pencil drawing, a fairly complete planning of the painting fixed in his mind and indicated with lines.

Having no fixed rule about where to start with washes, FitzGerald generally begins with a wash that involves a large area, often the sky. His starting point is often determined by the elements in his painting most subject to change, such as dominant shadow areas which will change position with the sun, water areas where tides are involved, and boats about to weigh anchor.

Similarly, FitzGerald has no fixed rule about painting from light to dark or the reverse, a procedure which is also dictated by the specific problem at hand. He often works on the dry sheet, and when he works wet, he seldom wets the *entire* sheet but only the section on which a wet-blend treatment is indicated.

FitzGerald's procedure in the studio is very similar to the one used outdoors, except that he takes much more time to complete a studio painting, often several days. His preliminary sketches take many forms: earlier watercolors may be used for reference; rough drawings, photographs, diagrams, even oils, or pastel sketches may serve as preliminary studies for a final watercolor. He often works out the drawing on bond or tracing paper and then transfers this to the watercolor sheet.

Step One: FitzGerald found this subject in a small boatyard at Perkin's Cove, Ogunquit, Maine. The larger boat is used as an ice breaker. A retired lobster boat with an odd pilot house resembling a telephone booth, this boat is owned communally by the Maine lobstermen and is stored at Perkin's Cove during the summer. As ice begins to form in late autumn, the boat is used to keep the harbor open as long as possible. FitzGerald made the drawing of the boat one August morning and estimated that for two hours the light would remain consistent enough for him to manage a quarter sheet (11″ x 15″) watercolor. He spent about 45 minutes composing a careful pencil plan for the washes of color, a drawing made directly on 120 lb. David Cox paper which had already been stretched. Since David Cox is a warm toned sheet, FitzGerald will use Chinese white to paint the few lights that appear in his "contre jour" composition.

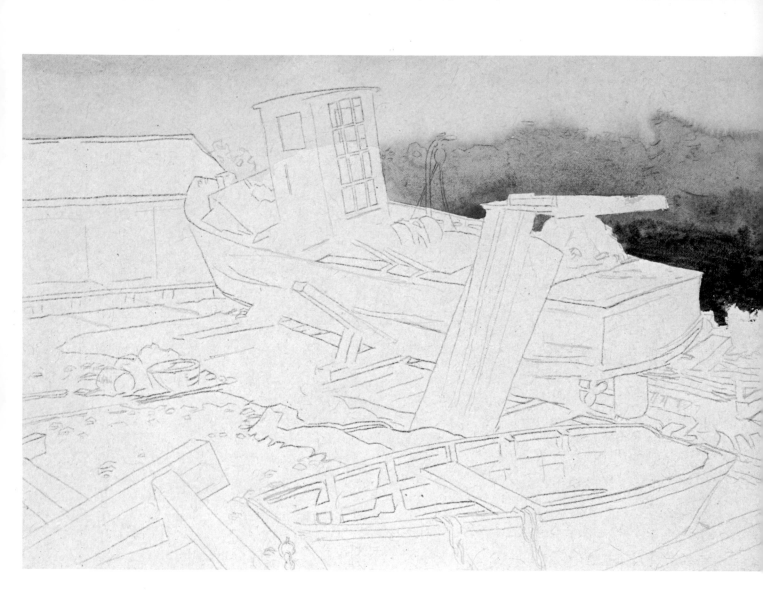

Step Two: In his first wash he completes the sky and establishes a preliminary tone for the bushes behind the larger boat. In the sky area he starts at the top margin with cobalt blue which is modified with a little Indian red; he quickly changes to yellow ochre well-thinned with water. While the sky is still wet, FitzGerald continues to wash in the bushes, starting with a strong value of yellow ochre and ultramarine blue, mixed beforehand. As he carries the wash downwards, he adds burnt umber and viridian.

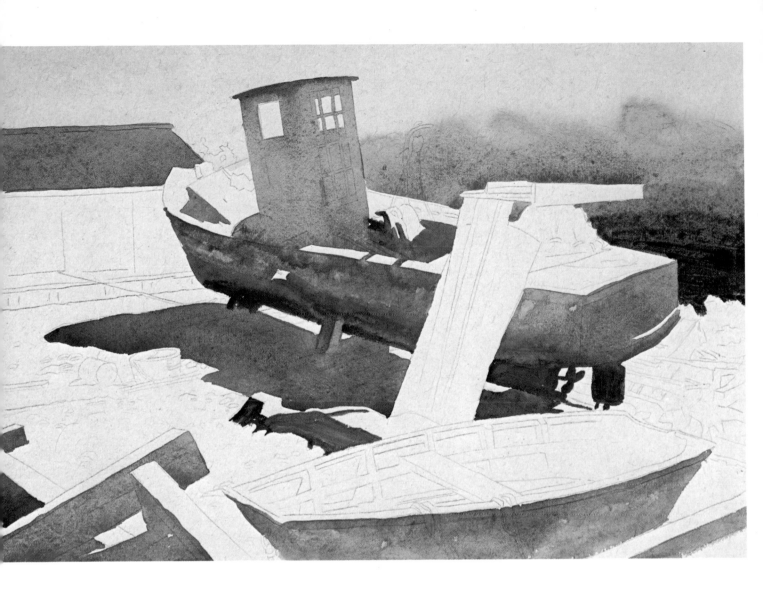

Step Three: Next FitzGerald mixes a large wash of cobalt blue, Indian red, and yellow ochre. With slight modifications during the painting, this mixture supplies the value of the gray shed roof and the soiled white of the two boats seen in shadow, as well as the large shadow on the ground and the silvery timbers in the foreground. The red paint on the bottom of the boat and the warm shadow on the cockpit are accomplished with strong infusions of Indian red during the painting.

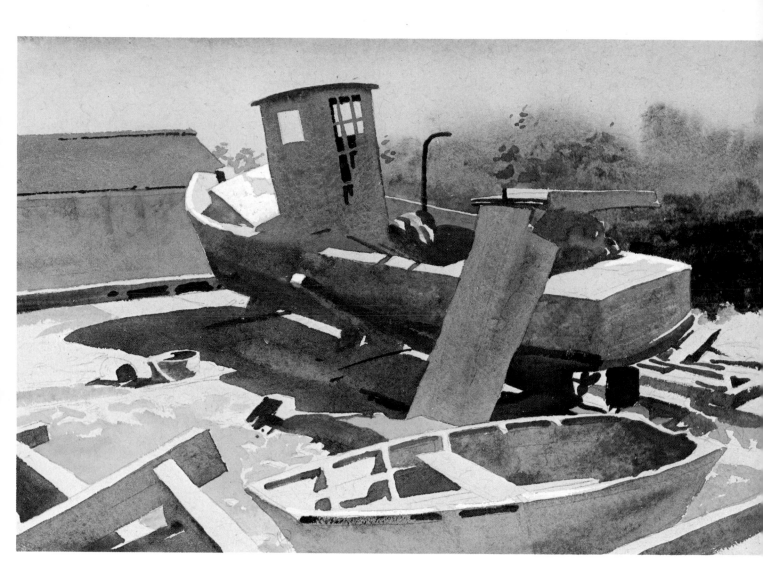

Step Four: Slight variations of the same mixtures used earlier produce the wall of the shed and the interior of the dinghy in the foreground, as well as the wooden structure lying across the after-part of the ice breaker and the shadowed parts of the litter on the ground. FitzGerald uses yellow ochre and cadmium red light to begin texturing the bushes. Dense mixtures of Indian red, ultramarine blue, and burnt umber provide the dark accents, and Chinese white is used to test the value of a few bright spots on the boats.

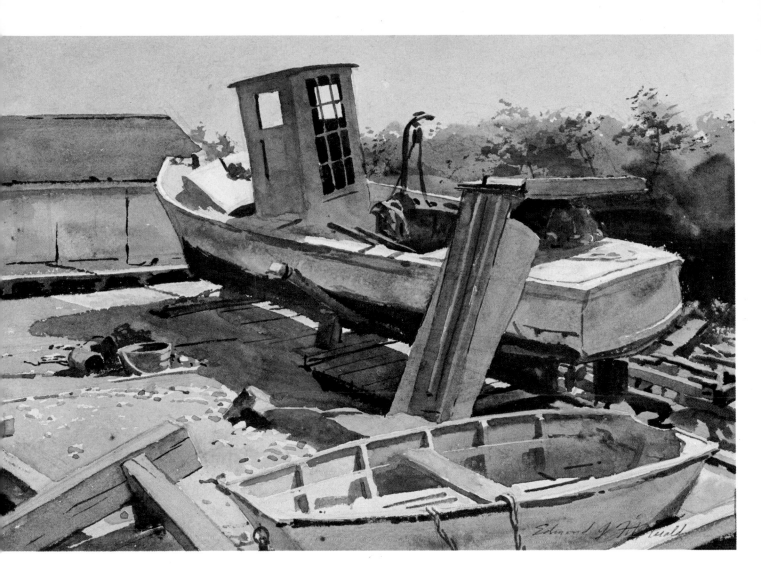

Step Five: Perkin's Cove Boatyard, 10¼″ x 14¼″. Next FitzGerald fills in the warm lights on the ground and litter, and Chinese white is added in the places — such as the deck of the ice breaker and the gunwale of the dinghy — where the light appears lighter than the paper. Pure cobalt blue trimming is painted on the dinghy and small dark accents here and there finish the painting. FitzGerald managed to complete the watercolor on-the-spot before the light had changed drastically.

Henry Gasser

In recent years Henry Gasser has changed his approach to his painting. Where formerly he painted in a loose and free technique, now he works more tightly: the forms in his painting are clearly delineated and his work reveals his present fascination with textures. Ink, which he applies in a spattering technique, has become an important means of emphasizing textural qualities.

When Gasser works outdoors, he sets up his paper—Arches cold-pressed paper in block form—on a folding stool and sits on another folding stool. For an architectural subject Gasser makes a fairly detailed drawing but only a rough sketch for landscapes. Working on location, he generally paints the sky first—on a dry surface—and attempts to work from dark to light in order to establish the picture pattern as soon as possible.

When Gasser works in his studio, he varies his procedure slightly: he paints on a tilted drawing board placed on a table and works on Royal Watercolor Society cold-pressed paper in 140, 200, or 300 lb. weights. (140 lb. paper is mounted on the board, with Sobo glue used to attach the edges of the paper to the board.) Working from sketches on which he has made penciled notations regarding the colors, Gasser paints from light to dark, having already established his pattern in the small spot sketch.

Gasser dampens the surface of his painting in the areas where he is placing broad applications of color, but he works on a dry surface when rendering textural details.

Whether he paints in or outdoors, Henry Gasser uses an extensive palette of tube colors: cadmium yellow light, cadmium yellow medium, cadmium orange, cadmium red light, cobalt blue, French ultramarine, cerulean blue, oxide of chromium green, phthalocyanine green, yellow ochre, raw sienna, raw umber, burnt sienna, sepia, Davy's gray, Naples yellow, ivory black, light red, and alizarin crimson. His assortment of brushes includes round sables numbers 3, 6, and 14; a 1″ flat sable; and a long sable rigger. Linear effects are made with a pen and ink (Higgins black, sometimes diluted). He does not hesitate to use liquid frisket for blocking out areas when needed.

One technique Gasser has been experimenting with is combining watercolor with an ink undertone. He concentrates on a pencil drawing of the subject first. Then with pen and black India ink, he begins the undertone. To avoid hard pen lines, he wets the paper with clear water; in some areas he simply dampens it slightly, in others he may apply the water freely. This way he can vary the ink lines. By spattering the inks over a moist surface, then using a brush for halftones, he achieves some interesting effects. He gradually works up a one-color rendering, without making this too definite. Later applications of watercolor washes—which he applies after the ink undertone is dry—sharpen the various forms. He uses well-diluted colors, transparent enough for the ink undertone to show through. He feels this technique offers excellent possibilities: it lends itself to working in a very loose manner, as well as a tight, almost photographic style.

Gasser generally works on any one painting over an extended period of time. As he approaches what he feels may be the completion of his painting, he places the watercolor in a white mat or in a natural linen inset (depending on the color scheme of his watercolor) to aid him in determining how much further he should carry the work.

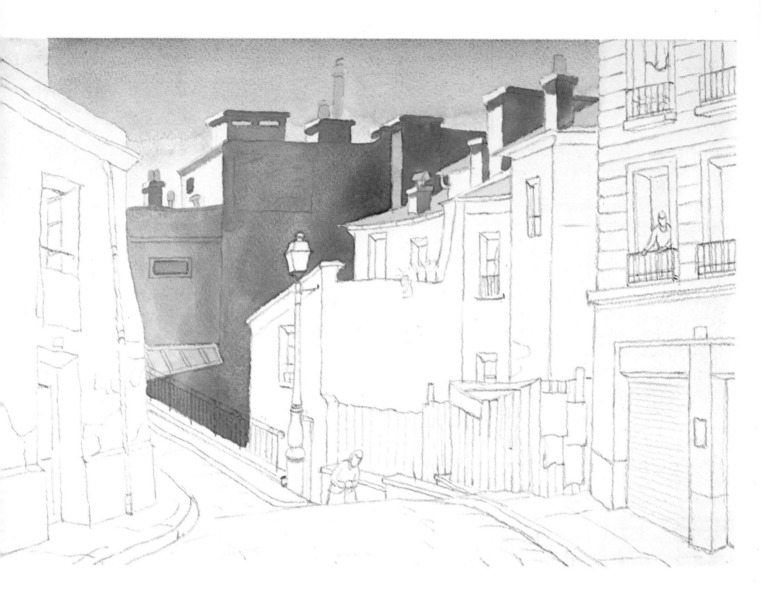

Step One: Gasser made a 9″ x 12″ pencil drawing—with color notations—on-the-spot in Paris. When he returned to his studio, he made a pencil rendering on his cold-pressed watercolor board, using his on-location drawing for reference. Gasser applies a wash of cobalt blue, mixed with a touch of raw umber, over the sky area. When this dries, he paints in a wash of cadmium orange over the chimney pots and a more highly diluted wash of the same color in the roof areas. The background buildings are then covered with a mixture of Davy's gray and touch of cobalt blue. Gasser leaves the white of the paper for the light areas in this building.

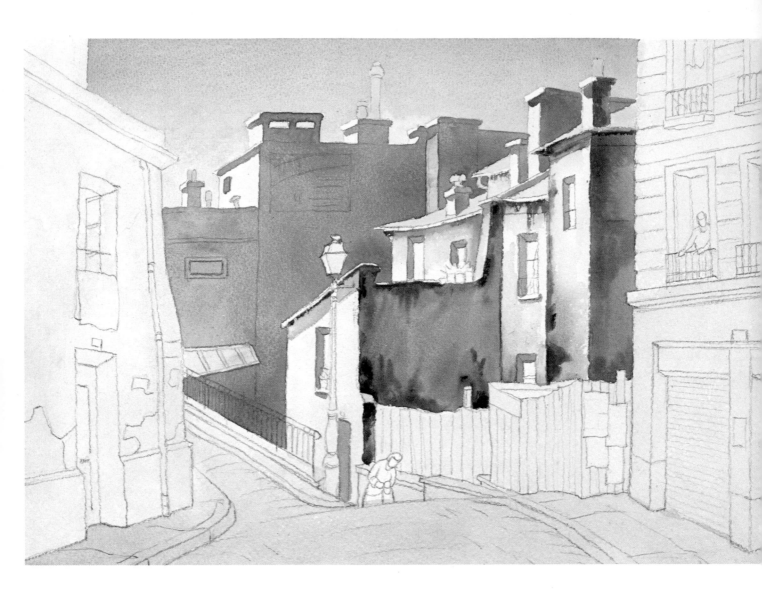

Step Two: Next Gasser paints the shaded areas of the middle ground buildings, again using Davy's gray, but in more concentrated form than he used for the distant building. While these areas are still wet, he adds touches of raw sienna, Payne's gray, and burnt sienna to suggest the stained and peeling surface on the buildings. Using a light wash of yellow ochre, he then paints the fence.

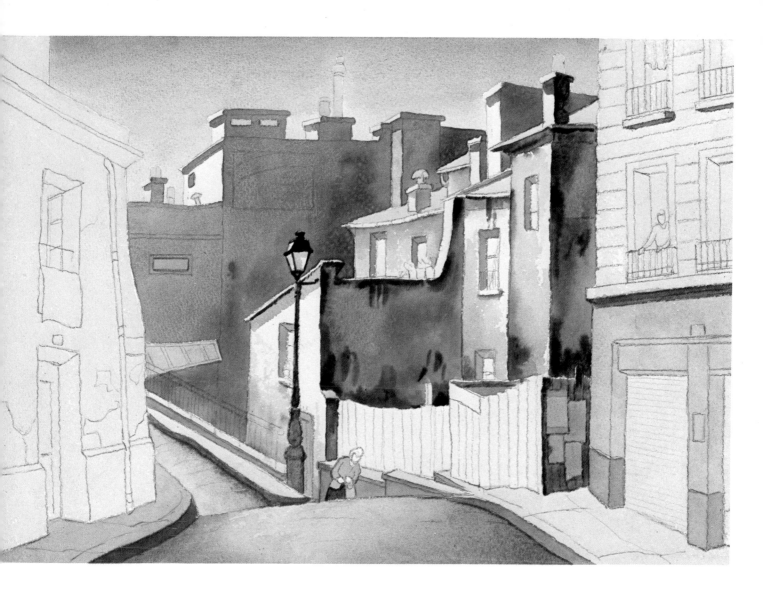

Step Three: Next Gasser paints the sidewalk and street, using Davy's gray for the lighter areas and adding Payne's gray for the darker areas. Payne's gray is brushed lightly over the lower part of the building in the foreground and over the shaded area of the fence. When this has dried, he paints around the posters with a mixture of yellow ochre and raw umber and uses a lighter wash of the same mixture for the building. Next Gasser indicates the colors of the posters. At this stage a light wash of alizarin crimson is sufficient for the woman's jacket, and ivory black is used for her skirt and for the lamp post.

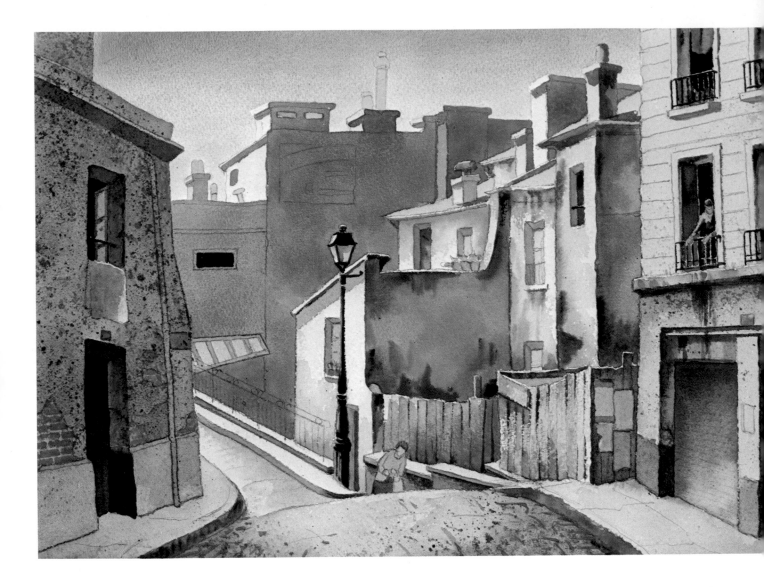

Step Four: The painting continues with a wash of Payne's gray and Davy's gray over the foreground building at the left. When this has dried, Gasser renders the bricks with light red, and using a lighter wash of the same color, he paints the rain pipe. A mixture of cobalt blue with a touch of phthalocyanine green produces the blue at the base area of the same building and this mixture (intensified) is also used for the doorway at the right. A touch of yellow ochre is added to the mixture for the lower area of the door. Gasser also paints the shutters with this intensified mixture. He adds the details by painting the cast shadows of the chimneys, the windows, flower pots, window frames, and so forth. When all this has dried, Gasser begins to texture the street and buildings by spattering ivory black. He varies the spatter occasionally by adding burnt sienna to the ivory black. To obtain the texture of the fence he drags his dry brush over the surface, using the same colors, well-diluted, with yellow ochre added.

Step Five: Street in Paris, 22″ x 30″ Gasser continues to texture other areas in the painting, combining a spatter technique with drybrush. (The stone surfaces of the building at left, for example, are textured with drybrush.) Finally, he sharpens up the details: the figures, the chimneys, fence, and so forth.

Tom Hill

The surface upon which Hill places his paper depends on where he is and what he is painting. In his studio he uses a large tilting 36″ x 48″ drawing board. He can tilt the board all the way from a horizontal position to a nearly vertical one, depending on his needs, and he either sits or stands to work.

For outdoor work a sturdy, folding wooden easel is employed. He can tilt his easel to any position, as he can his drawing board. This easel, with a little camp stool, presents a completely flexible arrangement. His outdoor equipment is lightweight for easy portability: he usually transports his brushes, sketch pad, palette, and other small gear in a kit or box.

Tom Hill has used all sorts of papers, from very thin and smooth, to very thick and rough, but he is partial to 300 lb. Crisbrook or 300 lb. Arches rough, preferring to stretch paper that is even this heavy. He soaks the sheet, lays it flat on a ½″ (or better a ¾″) plywood panel slightly larger than the paper, and staples all around the edges with a gun stapler. Then Hill allows the paper to dry in a horizontal position. Once it is dry, the sheet is as tight as a drum and any wrinkling or buckling that might occur is kept to a minimum. To prevent any wrinkling from occurring after the painting is completed, he waits for the sheet to dry thoroughly before removing it.

Hill's palette of tube colors varies, although he has some favorites. Normally he selects a cool and a warm of each primary, plus some assorted extras. For example, he might select lemon yellow and cadmium yellow medium, cadmium red light and alizarin crimson, ultramarine blue and Winsor blue, two of each primary. To this he might add cadmium orange, Winsor green, yellow ochre, burnt sienna, raw umber. In addition, he might include manganese blue, cobalt blue, viridian, cobalt violet, scarlet lake, and possibly burnt umber. He finds the phthalocyanine colors very brilliant, but because their staining qualities dominate most of the other colors, he uses them with caution. In his watercolor work, Hill uses an occasional acrylic color as well.

Hill's round sable brushes are of high quality: he uses the largest round sable manufactured by Winsor & Newton, the Albata number 14. In addition, he uses a number 10 of the same series and a touch or two is applied with a number 8. For large washes and wet-in-wet applications, Hill is partial to a 1½″ ox hair flat brush, or even a 2″ housepainter's brush. He enjoys the 1″ flat ox hair, too, and on occasion employs a natural or synthetic bristle brush, both to add paint and to scrub out or to lighten areas. Furthermore, Hill finds that sponges, tissues, blotters, cardboard, and mat knife are all useful tools, easily accessible when the need for them arises.

Hill works a great deal on location. Unless he knows a subject very well, he makes several drawings, a method of getting better acquainted. Coupled with these drawings are compositional studies, usually small, in which he attempts to solve the structure and design of his painting from the very beginning. Once he feels that he has resolved his painting, he proceeds by transferring his little thumbnail sketch onto the watercolor paper, a light indication made quite loosely.

He rarely paints in any specific sequence (top to bottom, or light to dark) but generally begins by wetting the paper where he wants soft edges or wet-in-wet. His object at the outset is to cover most of the areas as soon as possible with light and middle values, so that these relationships can be assessed early in the painting. Then he adds darks, extra brilliant touches, and any linear effects, remembering to stop somewhere half or two thirds along the way for a fresh look at what he has accomplished so far. Hill adds details to fit the desired result—either when the paper is still damp or later when it is dry.

Step One: Incorporating several on-location sketches, Hill completes the pencil stage of his composition. The pencil sketch is made with a 2B lead pencil, rather lightly, directly onto the sketched watercolor sheet. On-the-spot sketches record the details necessary to achieve authenticity, and when precisely transferred, provide Hill with an accurate indication of where he is going in the watercolor.

Step Two: In this stage Hill lays in the large light-to-middle values; a vital procedure accomplished in the first twenty minutes. Hill wets the lower and middle areas of the paper with clear water and applies yellow ochre and pale alizarin washes wet-in-wet. Next he adds the shadow sides of the sunshade awnings in cool and warm grays in the same wash. (Hill rarely uses black, preferring to mix more lively grays with color opposites. For example, ultramarine blue and burnt sienna give him a fine gray, made either warm or cool by adding more of one color than the other.) Saving the white paper that will represent the sunlit side of the awnings, he defines their shapes on the top by painting the negative shapes *behind* them. While the tree foliage area is still damp, he scrapes out some lights with the edge of his old mat knife. Next, he adds some flat washes to various areas: he washes scarlet lake over the dry paper to define the shape of the shopping bag at the center lower front; he does the same for the large carton in front of the figure in the upper left; and he washes in yellows, oranges, and purples in the areas that are to be under sunshades. He does this rather abstractly, leaving some pure white paper for the future.

Step Three: At this point Hill defines some of the things to come: basic shapes of flat color are applied to some of the figures, one color determining the choice of the next to some extent. He also adds a few darks at this stage, to clarify the balance of values. By this time, the washes at the top are dry, so he adds tree trunks. He then paints in the baskets at the lower left. He carefully places in a burnt sienna shape for each of the heads of the two men in the foreground. Although very little definition is needed here, Hill knows exactly how these heads will appear at a later stage.

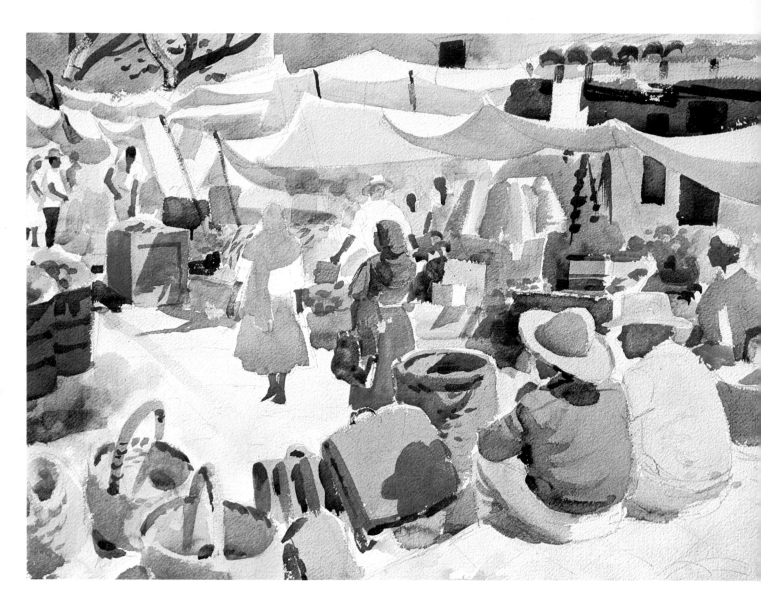

Step Four: Hill moves to the important details—to define the feeling of sunlight he paints shadows. These shadows are painted primarily in the same local color of the object, but modified with its opposite color (or near opposite, at least). While still wet, these shadows are often "charged" with other colors to indicate what is being reflected into them. More darks and some additional middle values are added. As each element is added, the one next to it is affected, further suggesting what he should add or modify next. ("The watercolor literally seems to grow before my eyes, sometimes seeming to possess a certain independence of its own!")

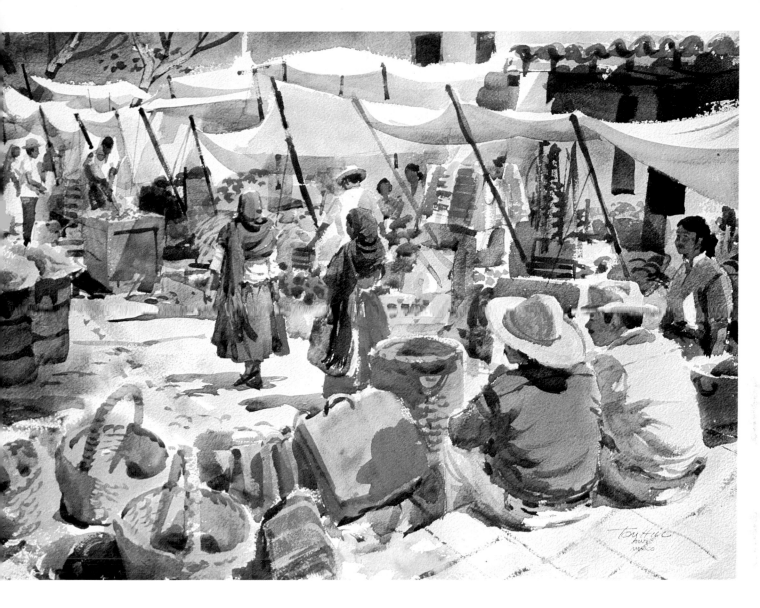

Step Five: Sunshine in Patzcuaro, 22″ x 30″. Collection, Mr. and Mrs. Dale
Chambers. Before making the final touches, Hill stops, steps back, and takes a fresh
look at the painting over a cup of coffee. Then he adds textures and linear effects
and tightens up the details to complete the painting. Had he not stopped, he might
have added too much, overworking the painting. This last stage then is one of real
evaluation, the final decisions being most crucial.

Philip Jamison

"Subject matter alone doesn't hold much interest for me," says Philip Jamison. Perhaps because he has this point of view, Jamison paints a wide variety of subjects—landscapes, interiors, flowers, and portraits—feeling that it is essentially the abstract qualities and the sense of feeling that make his painting unique, not the subject matter itself. Varied though his subjects may be, they are a direct statement of what he feels.

Since Jamison often tries to express the patina of time, his paintings tend to be subtle in color. He also uses neutral colors because they seem less tiring to him than the bright ones. (A tube of red, he points out, would last him for years.) His palette is limited, including the following colors: ivory black, sepia, burnt sienna, raw umber, raw sienna, yellow ochre, olive green, viridian, lemon yellow, Prussian blue, and Payne's gray. He uses only a few brushes: round sables numbers 2, 4, 8, and 12; a 1″ flat sable; and a 1″ wash brush.

Jamison has no single preference for paper, using a wide range of brands and insisting only that the paper is 100% rag. He stretches all the lighter-weight papers that are not already on blocks or board-mounted, and prefers a cold-pressed surface. When stretching his paper, Jamison tapes the sheet to a varnished ¾″ plywood board.

For painting outdoors, Jamison uses a simple folding easel, and indoors he works at a heavy tilt-top drawing stand. He begins his watercolor with an abstract pattern which is usually simple in design and color. "From this point, I start building with a good bit of enthusiasm and abandon," he observes. When possible, he tries to keep the painting in a fluid state so that he can push it around and make revisions. He works from light to dark on both wet and dry surfaces and rarely finishes his paintings in one sitting. In fact, some paintings have occupied him, on and off, over a period of years.

Step One: Jamison begins his painting on location at Vinalhaven, Maine. He draws in only the essential forms and is unconcerned with details. In this drawing he simply establishes the horizon line (which is very high) and the rock formations. Then he wets the paper and drops in two washes to distinguish the background tones of the distant and foreground areas.

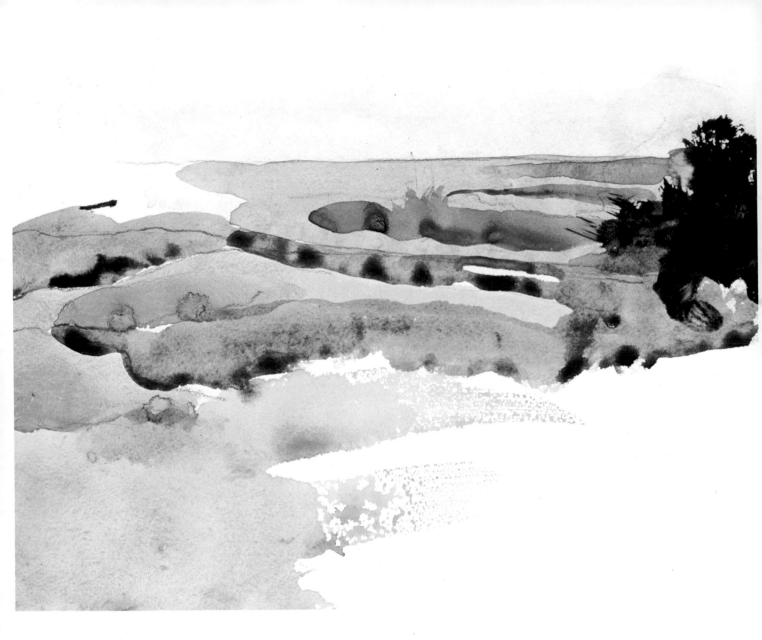

Step Two: Working from light to dark on the still wet sheet, Jamison covers as much of the paper as possible in the shortest time. In so doing, he establishes the lightest and the darkest values of the painting almost instantly. Using large brushes, he dashes the color onto the wet paper, making little effort to control the washes. This vigorous application sets the mood for the painting.

Step Three: Jamison continues to lay in color swiftly, still working on a wet sheet. He completes the foreground area of yellow and drops in the deep green foliage loosely. He pushes the pigments into place with his wet brush so that the bushes and trees form three major dark areas throughout the painting, each area having a different shape and density.

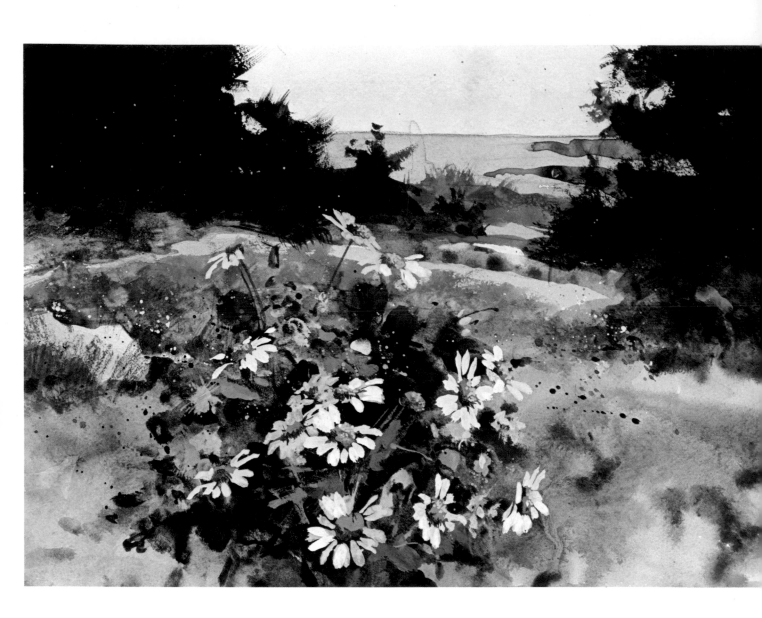

Step Four: Having begun the watercolor on location, Jamison brings the painting into the studio and works on a dry sheet. He begins to refine the painting. Opaque colors are introduced in the floral foreground. (Most of Jamison's paintings are created entirely in transparent watercolors, with opaques being used only in flower and plant forms.) Retaining the dark color key, he introduces white only in the daisies with flickers of brush strokes.

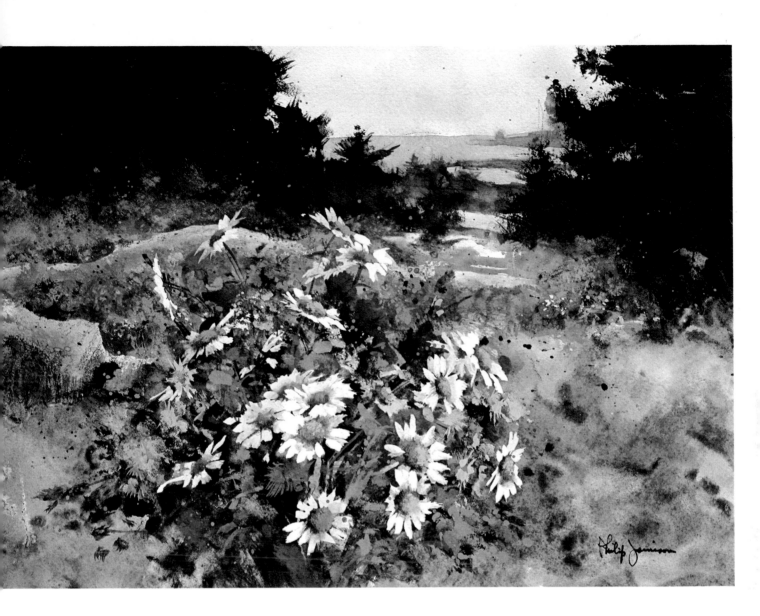

Step Five: Flowers on Ambrust Hill, 10″ x 13″. The foreground elements are refined even further. Using a dry brush, Jamison tightens the treatment of the daisies, texturing and modeling the flowers. Transparent applications of green watercolor over the opaque portions act as a glaze and give a richer color and texture to the arrangement.

Charles R. Kinghan

Having spent nearly fifty years in the field of commercial art, Charles Kinghan has been trained to look over every detail carefully before beginning to paint. In fact, this discipline has been so great that he has had to learn how to *eliminate* many of the details and to *simplify* certain passages. Studying from nature is what he calls "establishing a bank account." He urges his students to sketch from nature and to learn to interpret the textures of trees and old barns and the various kinds of grass, weeds, and foliage. After many years of having done just this, Kinghan now uses his camera wherever he goes and takes black and white photographs of what he wants to record. Although the composition in his photograph may be almost perfect, he usually finds it necessary to modify it by adding an object or by moving a tree. His years of sketching on the spot prevent him from copying the photograph too closely; he concentrates on his drawing and values.

When working outdoors, Kinghan unfolds his collapsible easel and takes out his paper, Royal Watercolor Society 140 lb. rough paper, which he stretches on a 20" x 26" x ½" plywood board. Kinghan always pencils in the details of the painting first with an HB pencil, then begins to paint. The sky comes first in his landscapes; if he wants a muted sky he wets down the area before he paints. If he intends to include some clouds, he wets only the underside of the sky area, retaining the white of his paper for the clouds.

After a certain part of the subject is dry, he adds more details. If he wants that area to remain soft, he wets the surface again so that the paint soaks into the paper, just enough to soften the effect without destroying the detail.

Sometimes Kinghan sets a watercolor aside until the next day so that he can have a fresh look at it. On other occasions he may finish the watercolor in a couple of hours.

Kinghan uses a rich and varied palette of tube colors: ultramarine blue, Rembrandt blue, cobalt blue, Prussian blue, cadmium red, alizarin crimson, brown madder, Van Dyke brown, raw umber, burnt sienna, raw sienna, cadmium yellow light, cadmium yellow medium, yellow ochre, olive green (Rembrandt), Payne's gray, and Hooker's green. His brushes include a 2" sabeline flat, 1" flat ox hair, number 20 round sabeline, number 14 round sabeline, number 10 sable, number 5 sable, and for big washes a 2" ox hair painter's brush. For textural effects he may use a sponge, and to obtain a fine white line he uses an emery board.

Having stretched his paper and taped the edges with a brown gummed tape, Kinghan places a mat over the sheet to eliminate the brown tape in order to better judge his composition.

Step One: First Kinghan completes the pencil rendering of the subject. Although this is fairly rough in the suggestion of landscape elements, the drawing is accurate in the placement of architectural details, the figure, and the dog. After making the drawing, Kinghan applies Maskoid on the roofs of the barns and the house. He also drybrushes some Maskoid in front of the trees at the left. While Kinghan waits for the Maskoid to dry, he prepares his first wash for the sky, the area in which he begins all his watercolors. In selecting his colors he concentrates on values. He selects a large brush for applying this wash.

Step Two: After mixing his colors, Kinghan applies the washes to the sky. In this case he uses a very light wash with a touch of yellow ochre, adding a bit of cooler color on the right-hand side as he approaches the hills. While the entire sky is still wet, he drops in the dark cloud, using Payne's gray mixed with a touch of brown. As the wash grades to the top of the trees, he switches to a slightly warmer color and continues this wash down to the middle of the tree line. He dilutes this gray color and puts in the small cloud on the upper right-hand side.

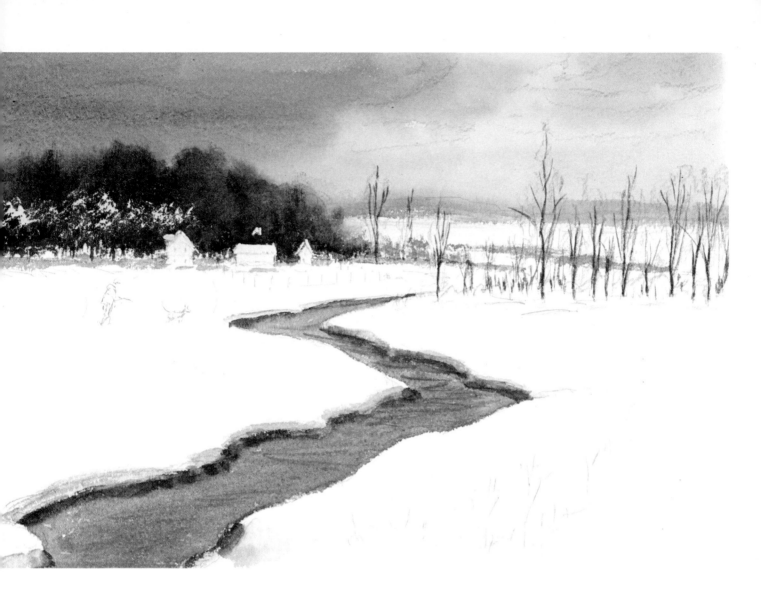

Step Three: Some sections of the sky dry more rapidly than others. To avoid an unevenly moist surface, Kinghan allows the sky area to dry completely, then—with a 1″ brush—he wets the entire sky again. He lets the painting sit for a short time until the sheet is evenly damp. When it arrives at the suitable degree of dampness, he adds the dark trees with Payne's gray and a touch of Van Dyke brown. In doing this, he goes right over the Maskoid and around the house and barns with his brush flattened out at the bottom so that the bottom tree line shows a rough edge. Then, with a small brush flattened out, he places in the small trees on the right side. Using a gray-blue, Kinghan lays in the water; it is slightly lighter and warmer at the top as it reflects the sky. After wetting the sky and waiting for this to dry, he places in the light blue hills with one stroke so that the top edge is muted, blurring into the sky.

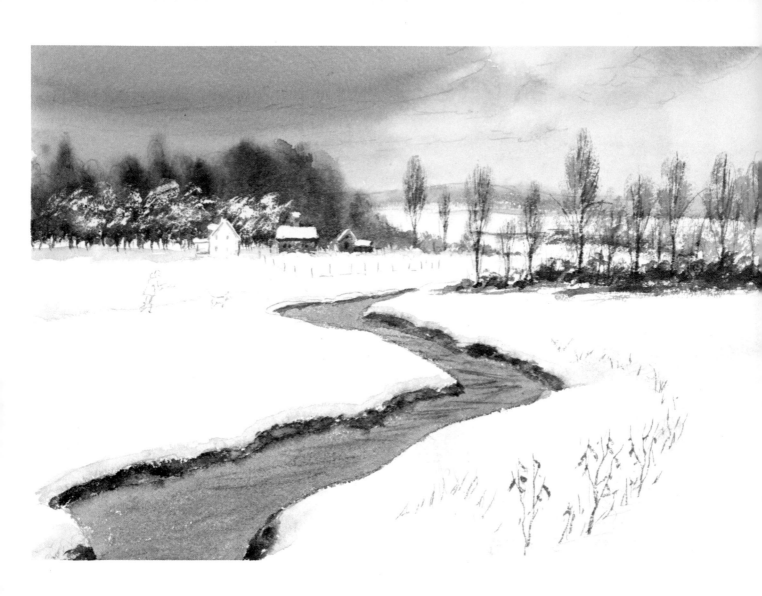

Step Four: Kinghan paints in the houses next, then removes the Maskoid. (Before doing so, he makes sure all these areas have dried completely.) With a number 4 brush flattened out and not too wet, he adds the light values on the trees on the right-hand side to indicate many small branches. Then, with a dark, warm color, Kinghan adds the bushes running along the bottom of the trees, again with a semi-dry brush so that he can leave a few whites in this bush area. With the tip of his brush, he indicates a few ripples in the water, then using his small brush—flattened out—places the small weeds along the stream. He adds a light gray tone along edge of the weeds. Kinghan wets the area where the man is walking and adds a light gray tone to give a roll to the snow.

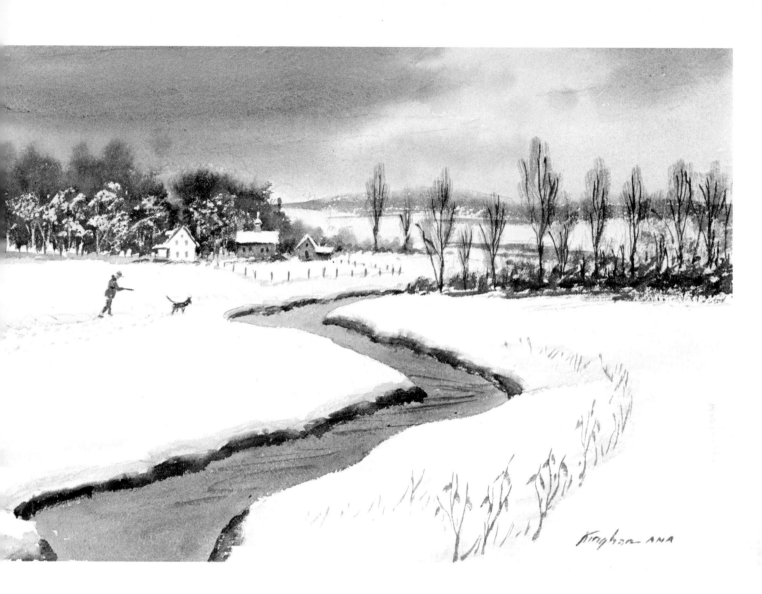

Step Five: Winter Day, 10″ x 13⅓″. Now Kinghan is ready to put in the man—a red coat with a dark fur collar and pants darker than the coat—and the warm gray of the dog. Kinghan then adds the footprints of both the man and dog. With a very light gray color he washes over the trees that have been treated with Maskoid so that the house emerges even lighter. Using the edge of an emery board, he picks out some tree trunks along the upper edge of the dark trees near the house.

Everett Raymond Kinstler

Everett Raymond Kinstler maintains that, "As a medium, watercolor consistently provides the strongest contributions to our art exhibitions and is most appealing to the American temperament. It suits our personality, due mainly to its openness, spontaneity, and plain old impetuosity." Kinstler succeeds in capturing the essence of this "American quality" in his watercolors.

Kinstler's palette of tube colors contains cadmium yellow, raw sienna, cadmium red light, alizarin crimson, burnt sienna, raw umber, cerulean blue, phthalocyanine blue, and phthalocyanine green. He usually uses only about six brushes, including a 1½″ flat, a ⅝″ flat, a number 8 round, a number 5 round, a number 3 round for detail or fine brushwork, and one rigger or general utility brush for scrubbing or drybrush effects. He will occasionally use a razor blade and small sponge for other effects.

Indoors Kinstler paints on a table, outdoors on a portable easel. His studio palette, an enamel tray about 18″ x 25″, lies flat on a nearby table. (On occasion he uses a glass palette with a sheet of off-white butcher's paper affixed to the underside.) Kinstler prefers painting on 300 lb. paper but varies his selection of brand and texture to meet the particular requirements of his painting. Sometimes he works on a watercolor block for quick impressions. Rather than mount his paper on a board as so many watercolorists do, Kinstler stretches his paper on canvas stretchers. He prefers the tautness and springiness achieved by stretching in this method.

Usually Kinstler makes a quick notation of his subject before proceeding to the final sheet, transferring his sketch very loosely, since he prefers to sharpen and refine his drawing later, directly with the brush. In this way he can have maximum freedom and obtain the freshness so characteristic of his painting. His drawing, therefore, serves merely to compose and place the elements in his picture.

Because he likes to work with both wet and dry paper, Kinstler has no fixed procedure, except to keep the entire picture working at the same time rather than concentrating on one area first, another second. He does try—for the most part—to complete his watercolors in one session. The final size of his painting is often determined by how it appears under a mat, and he places a variety of mats of different sizes over the painting. This suggests to him how to crop or shape the watercolor before it is framed, and he may ultimately cut down the composition as a result of his examination under the mat board.

Step One: Using an 8″ x 11″ French watercolor pad paper having almost no texture and a small Winsor & Newton pan box, Kinstler painted the following portrait in about thirty minutes. It was the only one of dozens of watercolor sketches that found its way into a frame. Most are discarded or form the basis for other watercolors. To begin, Kinstler roughs (in pencil) a basic outline of the head for placement and proportion. The sketch is not detailed because he finds that too careful a drawing is confining and restricts his freedom. He also feels that a child's portrait should be direct, simple, and fresh, qualities that are best achieved with little planning.

Step Two: Working transparently, Kinstler paints around the white paper, using it as a basic light area. As he does in oils, Kinstler first lays in the overall halftones. Here he uses raw umber and cerulean blue, attempting to retain a certain wet feeling. In all his portraits—whether in oil or watercolor—he makes no conscious effort to achieve likeness, but suggests mass and structure first.

Step Three: In this stage, Kinstler builds up the darks. He also lays in several washes of flesh color to add dimension to the head. He maintains a consistent approach to develop the entire portrait at the same time, without focusing on any particular details. The features are suggested, but not refined. He keeps the overall effect somewhat "out of focus," knowing that he can sharpen the details at a later stage.

Step Four: Still saving his white paper for the light planes, Kinstler sharpens up the general features, intensifying the degree of shadow and introducing more delineation. Kinstler operates by instinct, and in trying to keep his effect simple and open, accidents occur which he takes advantage of. For example, as the background slides into the hair, interesting transitions occur. Rather than sharpen the distinction between hair and background, Kinstler decides to keep the effect soft.

Step Five: Dana, 7″ x 10″. In the last stage, Kinstler strengthens the shapes, including the hair, losing some edges as he develops particular transitions for the sake of likeness. Finally he erases the pencil marks. Although he has been working less than a half an hour, Kinstler does stop occasionally to allow some areas to dry. At other times he works wet. He has attempted here to suggest with color what initially appealed to him: the freshness of a two-year-old child. According to him a child's face is more difficult to paint than that of an older person because the child's face is so devoid of planes and structure.

John C. Pellew

John Pellew has developed his broad confident method of working by sketching and painting from nature for many years and by studying the masters of watercolor, particularly DeWint, Bonington, Sargent, and Homer. Pellew works straightforwardly, with little reliance on materials other than his tube watercolors and brushes. (Although he carries a razor blade, sponge, pencils, and a knife with him when he works on location, he rarely uses them.) Even his colors and brushes are small in number. His palette of tube watercolors includes gamboge yellow, yellow ochre, raw sienna, burnt sienna, cadmium red light, alizarin crimson (which he seldom uses), phthalocyanine blue, cerulean blue, and burnt umber. He carries no greens, preferring to mix these colors with combinations of yellows and blues. His brushes include 1″ and 2″ flat sables, and round sables numbers 8, 6, 5, 3, and 2.

When working in the field, Pellew prefers the Anderson (or Gloucester) easel. Although designed for oil painting, the Anderson easel is his favorite for watercolor as well: it folds into a compact package, there are no screws or wing nuts to get lost in the field, and it is sturdy when opened. As he paints, he holds a folding palette in his left hand.

Generally Pellew has used 300 lb. cold-pressed paper which he does not stretch but fastens to his board with masking tape at each corner. However, Pellew has recently discovered that a smooth, two-ply surface also produces arresting results. Effects impossible on the rough or cold-pressed surface come easily on the smooth sheet.

For landscapes that do not include buildings or structures, Pellew indicates his composition with a brush and diluted burnt umber. For more complex subjects, he sketches first with the pencil, not a detailed drawing but a general indication of the placement of objects. Then he begins to paint, first the sky, then the other areas from light to dark, with the darkest darks placed last.

Out of doors, Pellew works directly on dry paper. In the studio he occasionally works on a presoaked paper. Pellew rarely works from sketches. The exceptions are his street scenes which he paints in the studio from pencil drawings made on the spot. Even when he refers to these sketches, he does so freely, allowing his visual memory to work. Some detail is added while the paper is still damp. More definite washes and final touches are added when the surface has dried.

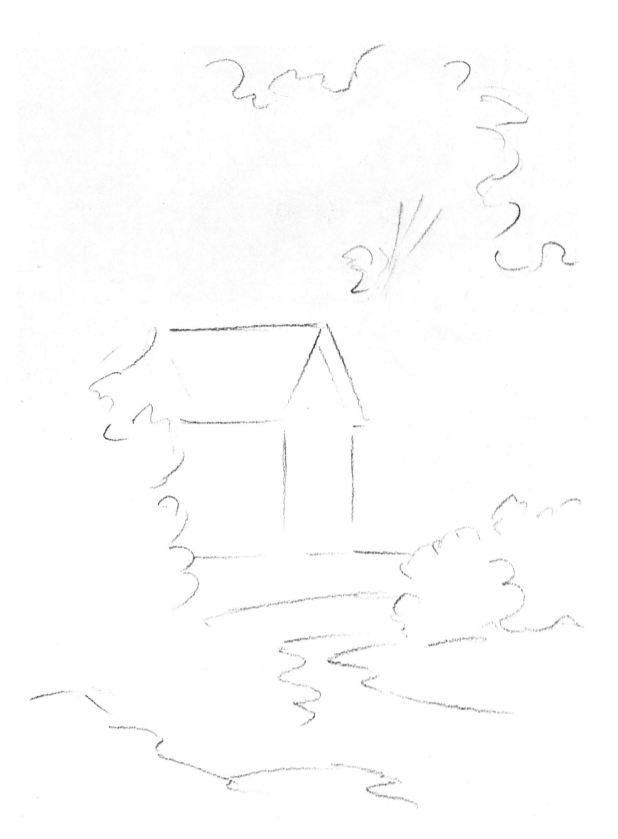

Step One: This is the extent of Pellew's pencil work for a watercolor: only the main shapes sketched in to establish the composition. Care is taken to keep the eye level below the center of the picture space and to have most of the house left of center. Pellew drops in a pale wash over the sky and the trees behind the house, a warm tone made by mixing cadmium red light, phthalocyanine blue, and a little yellow ochre, diluted in a good deal of water.

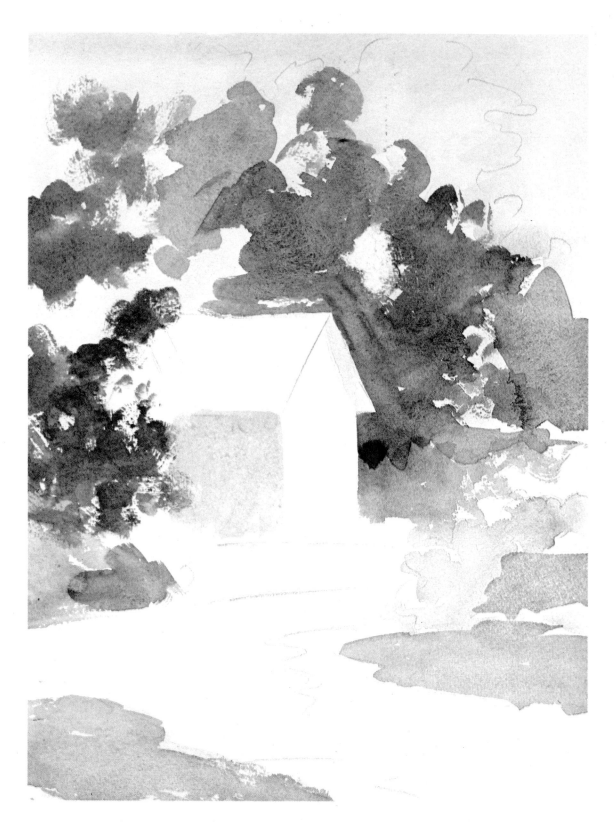

Step Two: At this stage Pellew applies some simple color washes, more as a compositional guide than an application of precise color. Since these will be pretty well covered by other washes, he makes no attempt to establish final tonal values here. A very pale tone of phthalocyanine blue is painted over the sky, done rapidly in order not to disturb or pick up the warm undertone. Next Pellew indicates the shadowed parts of the house and the muddy banks of the stream. For these areas he uses warm grays made from a mixture of phthalocyanine blue and cadmium red light. The side of the house is lighter and warmer than the foreground banks.

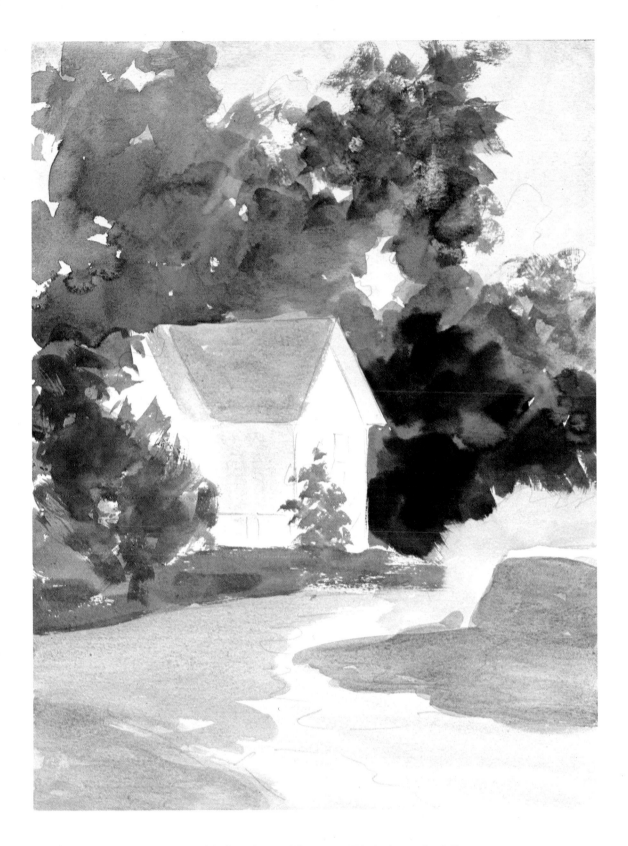

Step Three: Next Pellew establishes the middle tones. He darkens the foliage areas with a variety of color mixtures (involving the use of yellow ochre, raw sienna, burnt sienna, and burnt umber). The sky, the shadowed side of the house, and the lightest foreground tone are created by using mixtures of cerulean blue and cadmium red light. The roof is a darker mixture (made with less water) of the same two colors. These colors, with a little burnt sienna added, constitute the color for the big shapes left and right in the foreground.

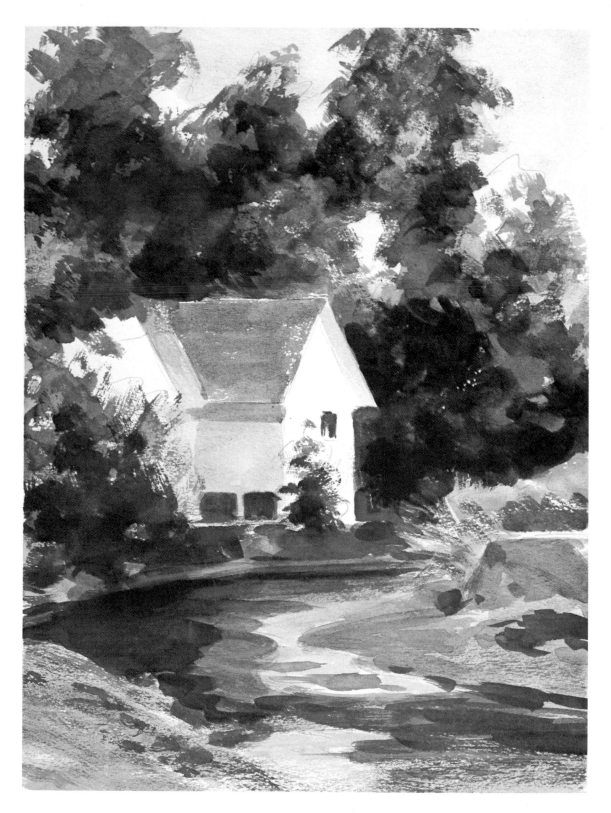

Step Four: At this point it is simply a matter of building up the darks before adding the final details. To obtain the deepest darks in the foliage, Pellow uses mixtures of raw sienna, burnt umber, and Payne's gray, placing these tones rapidly with a large brush (number 9 sable). He is careful not to scrub up the underwash which would destroy the luminosity by producing a muddy color. Next he works on the foreground, developing a pattern of lights and darks and some drybrush texture. Here again he uses cerulean blue, cadmium red light, and burnt sienna. For the darkest darks he uses burnt umber and Payne's gray.

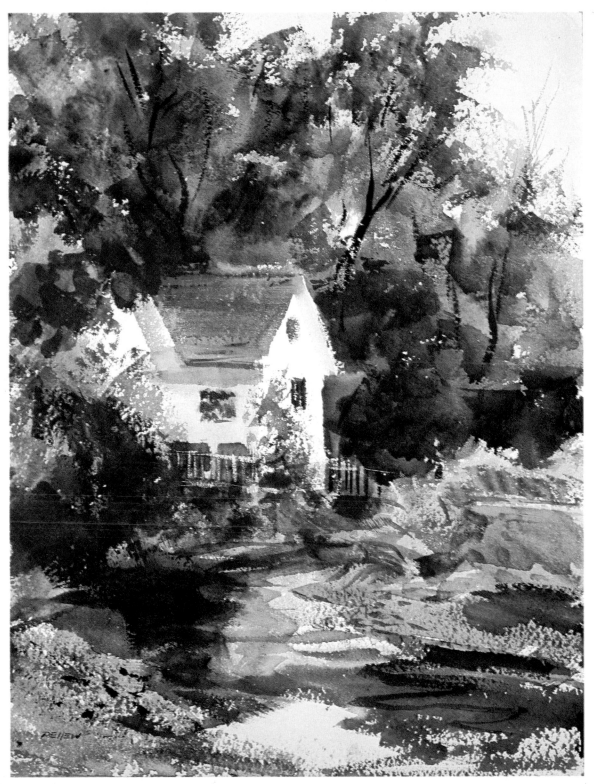

Step Five: The White House on Stonybrook, 16″ x 20″. Pellew resists the temptation to overwork details, so he adds very little to the watercolor at this stage. Drybrush maximizes the textural interest, and Pellew scratches out pigment in the foliage where he wants more "sparkle." This quarter sheet watercolor was painted on location in Westport, Connecticut, on 140 lb. Capri cold-pressed paper which Pellew fastened to a 16″ x 20″ Masonite panel with masking tape. Only two brushes were used throughout: a number 9 and a number 5 round red sable. This painting is what the artist calls a "quickie," as it took him less than half an hour to paint. Pellew believes that the best on-the-spot watercolors are painted rapidly.

John Pike

In reflecting about the qualities of watercolor, John Pike commented, "I am definitely not of the 'slop it on, fight, scrape, mop up, and hope school,' but I do worry and cry a bit." Regarded by many as one of the contemporary masters of watercolor, John Pike does not subscribe to any single method in his work. He does not work traditionally, but tries instead to cover the full range of the possibilities inherent in watercolor by using water only in the areas where he wants it wet and by keeping the sheet dry where he wants it dry, concentrating primarily on the value relationships in his painting.

As an artist who frequently teaches by demonstrations on the spot, Pike decided to construct his own equipment to facilitate his needs: he designed and built of aluminum a collapsible tripod easel with an attached side table used for holding water, palette, brushes, and paints. Within this contraption he carries a dozen or more full sheets of paper. In his studio he paints simply on a large, flat table.

Arches 300 lb. cold-pressed paper is his favorite; he prefers the cold-pressed surface because it contains enough tooth for texturing but is also smooth enough to enable him to lay on a faster wash than he would with the rough. He does not stretch the 300 lb. paper. In addition to the Arches, Pike still owns quite a few sheets of Whatman's double elephant —both mounted and unmounted—a sheet no longer easily available.

Pike works with a limited palette of tube watercolors: ultramarine blue, phthalocyanine blue, phthalocyanine green, alizarin crimson, cadmium red light, gamboge hue or new gamboge, burnt sienna, burnt umber. He uses only a few brushes: 1½″ flat ox hair, 1″ flat ox hair, ⅝″ flat ox hair, number 8 round ox hair, and number 4 and 6 sable riggers.

Additional materials include a knife for that occasional "twig sparkle," a sponge—only for washing off the sizing found on many heavy papers, cleansing tissue—only for cleaning his palette, and a hairdryer which he uses just in his studio. (He built a 3000 watt hairdryer that he calls "Monster" which he took to New York for a demonstration and had the dubious distinction of blowing out the lights in the National Academy with it!) His use of rubber cement and liquid frisket is limited.

Whether working outdoors or in, Pike always makes a careful black and white value sketch to identify the light, middle, and dark areas, and he adheres to this plan in his painting. This sketch is his "blueprint" in which he composes, rearranges, and simplifies to suit himself, but its greatest importance is in its establishment of values.

Pike almost invariably works from light to dark, but this rule, like most in watercolor, has been broken many times. The subject matter really controls his procedure.

Pike does not soak the entire surface of the paper. If he wants a soft passage he wets that area with clean water and drops in his pigment. If he wants the passage to be hard or crisp, he works on a dry surface.

Pike attempts to complete a watercolor at one sitting and usually can because he preplans so carefully. However, much in the way of time depends on the complexity of the subject and the difficulty of its execution.

To check his composition Pike lays down a trial mat or holds a small hand mirror (he uses an old Army signal) over the painting to study his watercolor in reverse. Any faults in drawing and composition quickly become obvious.

Step One: The general shapes are first drawn in lightly, so that the proportions are established over the entire sheet. Staccato lines already indicate the movement of the painting. Then Pike applies a small amount of liquid frisket—indicated by the darker lines in the reproduction above—to save the highlights on the rocks and on the water. Liquid frisket is like a thin rubber cement and prevents later applications of pigment from touching the white paper. When the frisket is dry, Pike wets the entire surface and lays on a light warm gray wash, darkening it, left and right, to intensify the light path down the middle.

Step Two: After allowing the preliminary wash to dry, Pike brushes on clean water over the areas of the sky and the big wave. While these areas are still very wet, he paints in the dark sky around the waves, allowing the pigment to run and form the soft, blurry edges. The distant sea and misty palms are placed at the same time — a busy moment for Pike! The artist could have achieved a similar effect by "mopping up" the color already applied, but Pike finds that his method of painting the dark elements around the light waves produces cleaner results. Finally he removes the liquid frisket.

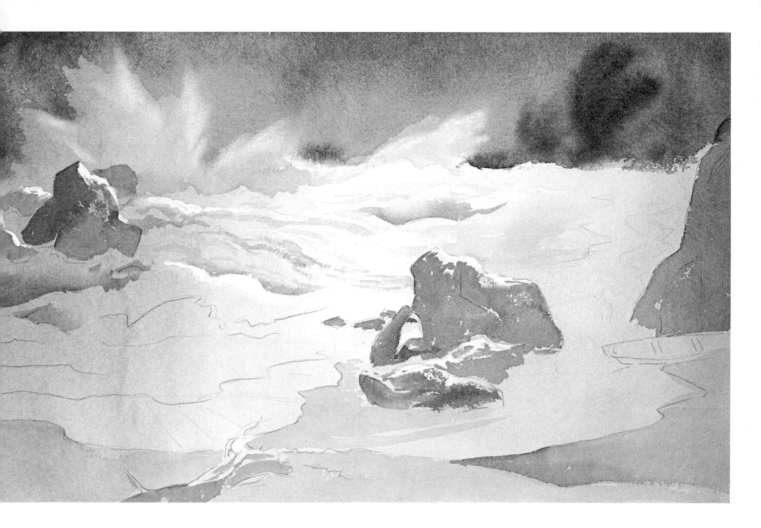

Step Three: At this point Pike starts to model the surf in the middle ground. (Pike confessed later that he wished he had chosen a subject with a few square hard edges which would have greatly simplified this stage!) A warm wash is then put over the exposed sand areas and the rock shapes are established with a gray made by mixing ultramarine blue and burnt sienna. He will texture and darken this area later. As he paints, he keeps in mind that the light should remain intense, coming from directly above.

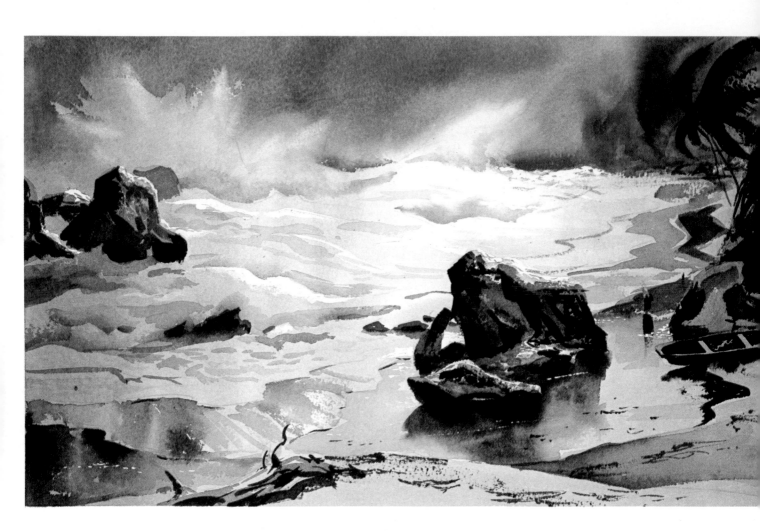

Step Four: At this stage Pike pulls together the textures and values. Although still not completed, the painting clearly reveals that the value relationships have been established to create the desired atmosphere of a violent churning sea. This stage is most crucial to the painting. The rocks are darkened and textured, and washes of color are placed to suggest the shadows looming on the wet beach. The figures and boat are painted in with a small brush.

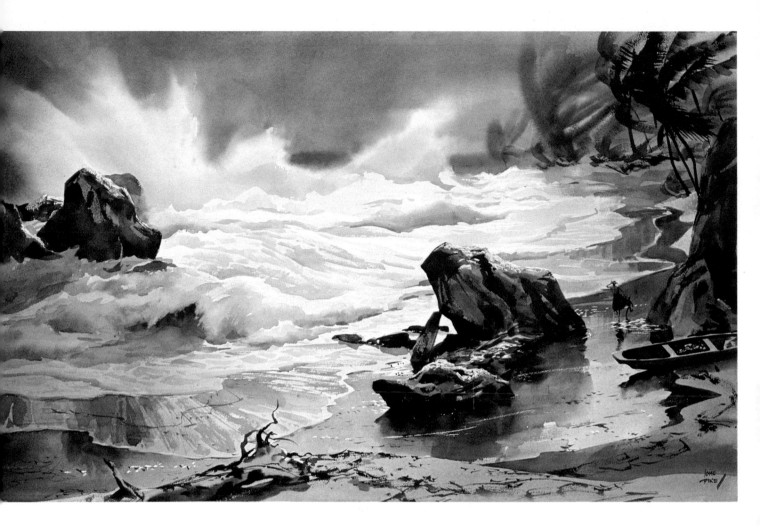

Step Five: Brewing Storm, Jamaica, 24″ x 38″. Small touches are added, primarily
with a dry brush. Pike textures the highlights, runs his brush along the beach, com-
pletes the tree washed on the shore, and tightens up the figures. These are small
details, designed to create interest. The feeling of depth has already been conveyed
in the third stage, for this is where Pike established the values.

Henry C. Pitz

After having spent many years rendering subjects as he saw them, Henry Pitz now uses his subjects simply as points of departure from which his imagination takes flight. Design and color are most essential, and he often begins his paintings with nothing more than a few rather abstract washes. Frequently he mixes different media to enhance a given effect: inks, acrylic colors, or gouache can be combined with transparent watercolors in any painting. Even an occasional touch of pastel can be incorporated.

Since Pitz generally paints only small sketches outdoors, he does not bother with a sketching easel, but works instead on a pad or in a sketchbook which is held in his lap or placed on the ground. His outdoor sketches are brief, brushed in with little or no preliminary drawing.

Usually Pitz completes his paintings in the studio, where he prefers to paint flat on a drawing table or on the floor. His palette of tube colors includes lemon yellow, cadmium yellow medium, yellow ochre, raw sienna, burnt sienna, cadmium orange, cadmium red medium, ultramarine blue, and permanent green. To this list he occasionally adds ivory black, zinc white, cerulean blue, sepia, or Prussian blue. His assortment of brushes includes red sable rounds number 3, 5, 10, and 12; ½″ and 1″ flats; and nylon varnish brushes in 2″ and 3″ sizes.

Formerly, Pitz used Whatman's cold-pressed 133 lb. paper almost exclusively. Because this paper is now very scarce, he resorts to a number of different sheets: Arches cold-pressed 72 lb., 140 lb., and 300 lb.; Royal Watercolor Society in 72, 140, and 200 lb. weights; Fabriano 72 lb.; and Green's 300 lb. (His sheet is normally 22″ x 30″ in all cases.)

Pitz begins a painting in one of two ways: either he works from a brief outdoor sketch, or he makes a pencil drawing on his sheet and adds enough color to indicate the overall impression.

Most details are left until the surface is completely dry. He was taught that the only way to paint a watercolor was to complete it in one sitting, but he soon discovered that was nonsense, and now he paints as the mood dictates, rapidly or slowly. Sometimes he puts a painting away for weeks or months before completing it. He asserts that he spends more time contemplating the painting than he does actually working on it!

A trial mat, placed over his painting periodically, helps him judge the composition as he proceeds.

Step One: Over a very rough pencil drawing Pitz swiftly brushes the paper with liquid washes, principally to indicate the darker foliage mass of the background and the jagged edges of the cliff below. Then he establishes a few basic aspects of the foreground to provide an approximate framework around the light chalky area of the cliff side. The form of the gliding hawk is painted over with Maskoid for protection so that Pitz can sweep freely over it when painting the background washes.

Step Two: The background and cliff edges are then more definitely developed. Pitz strips the Maskoid from the bird form, showing it now as a white silhouette. He continues to paint from the top downwards, roughly indicating the foreground with pale washes which are only suggestions of form. These washes are subdued in value, to be intensified as the painting develops.

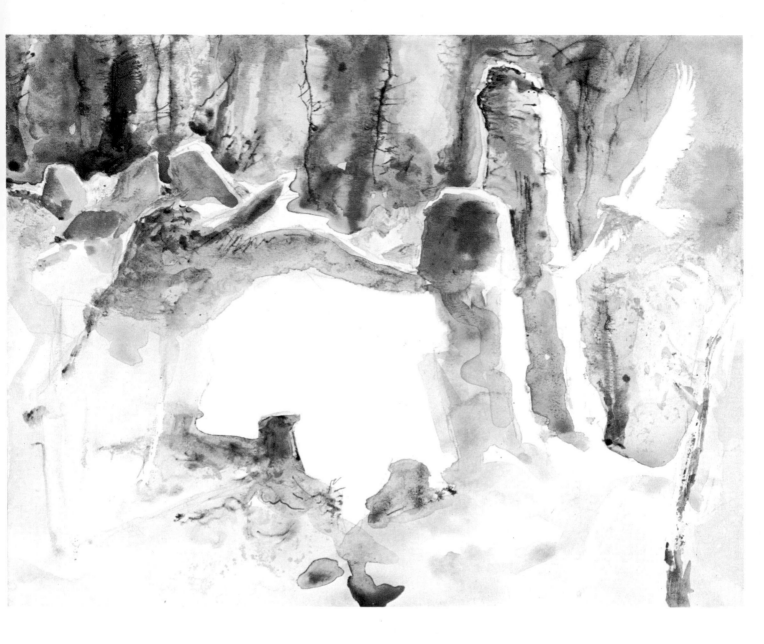

Step Three: The artist proceeds to establish more positive relationships, now moving over the entire painting. A brushstroke or two changes the flat hawk silhouette into something more solid. The rocks, too, take on more form as Pitz applies washes of burnt sienna and raw sienna to strengthen their character.

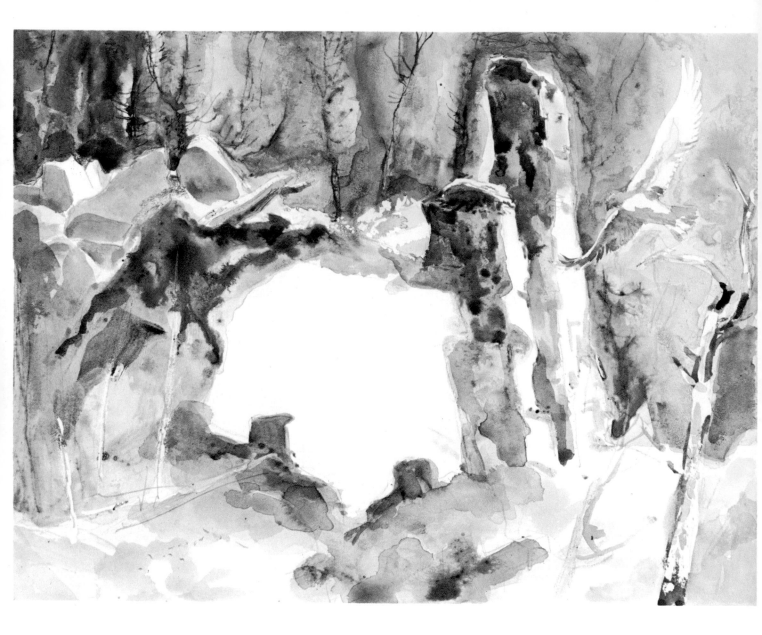

Step Four: More accents are brushed in with the earth colors and the painting begins to take shape. As the pigments mingle, they form interesting textural passages. The chalky patch of the cliff side is left untouched at this stage. Only toward the end will this area be lightly conditioned with drybrush texture and tone. Its shape is too important to the picture to be blurred or lost into the gray hillside.

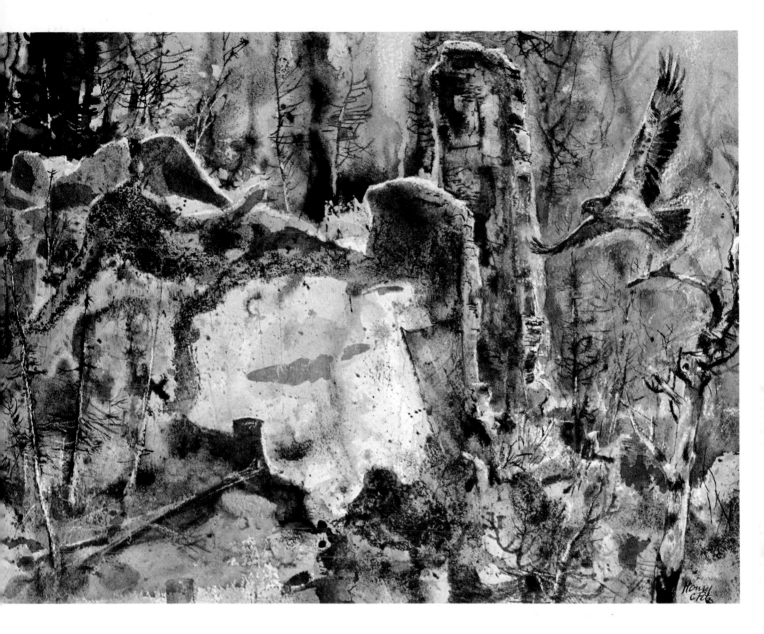

Step Five: Lonely Flight, 18½" x 24". The last half hour is usually a time of sharpening edges and defining forms. Pitz softens some edges and sharpens others. Raw sienna is used extensively at this stage, deepening the overall tones of the painting. Spatter and stipple provide an atmospheric texture, and Pitz tones down the light side of the cliff by dropping in pigments that appear in other sections of the painting. Linear effects are added last on a dry surface.

Michael Rossi

The characteristic quality in Michael Rossi's work is *simplicity:* a strong sense of design and a minimal division of shapes and colors used to create a degree of abstraction that is very appealing.

When painting out of doors, Rossi uses an Anco collapsible wooden easel of medium weight. He has also painted outdoors without an easel, clipping the paper on a slightly larger piece of Masonite and placing it on the ground or on a small rock or stump. Painting in the studio, Rossi finds it most convenient to work on an adjustable drawing table.

The tube colors Rossi places on his palette include burnt umber, raw umber, burnt sienna, raw sienna, yellow ochre, cadmium red, alizarin crimson, lemon yellow, ultramarine blue, Winsor blue, Hooker's green dark, phthalocyanine green, mauve, Davy's gray, Payne's gray, ivory black, and white tempera. For brushes, he favors the highest quality red sable flats, ½″ up to 1½″; number 4 and number 2 riggers; oil bristle number 6 flat; and round red sable number 12.

If Rossi can still find any Whatman sheets (they are no longer manufactured), he uses them in 140 and 300 lb. weights in rough and smooth; he also enjoys the Whatman board, equally difficult to find. Unable to locate these, he will use Fabriola 140 lb. and Arches 140 lb. and 300 lb. sheets. He never works on watercolor blocks and never stretches paper, preferring to use large spring clips to control a wet sheet if necessary.

Rossi's other tools include knives, razor blades, sponges, erasers, charcoal, tissues, a small electric heater for his studio, pen quills, a putty knife, felt markers, and flat graphite layout sticks.

When painting outdoors, Rossi may work directly on the watercolor paper without any preliminary sketch at all. Or he may make a small value pattern sketch, using charcoal, felt markers, or a graphite layout stick. He then roughly pencils in this sketch on the watercolor paper before wetting the sheet. He interprets his sketches loosely. In fact, the finished watercolor may have very little resemblance to the original sketch.

Rossi generally works from light to dark, painting in the most distant area first. (If there is sky, he paints this first, for example.) He works on a water-saturated surface for some paintings and a combination of wet and dry for others, depending on the subject and the final effect he wants to achieve. Soft areas are almost always painted wet-in-wet. Details are generally added when the paper is dry, (although occasionally he adds a detail before the paper is quite dry).

The major portion of his painting is completed in one sitting. If the design and mood are established in one sitting, details or finishing touches can be added in one more sitting without his losing the freshness or mood of the piece.

Rossi often uses a trial mat during painting and occasionally resorts to a smaller mat, shifting it around as he would a view finder, to see if he can improve the design by cropping out an uninteresting area.

Step One: In his studio Rossi makes a pencil drawing directly on his Whatman cold-pressed watercolor board, using a rough 7″ sketch made on the spot for reference. With a 1½″ red sable, flat lettering brush, he then brushes clear water over the entire board and paints the sky with a mixture of Davy's gray and mauve. He continues the wash, grading from a deep gray at the top of the sheet to a neutral gray as he approaches the background foliage.

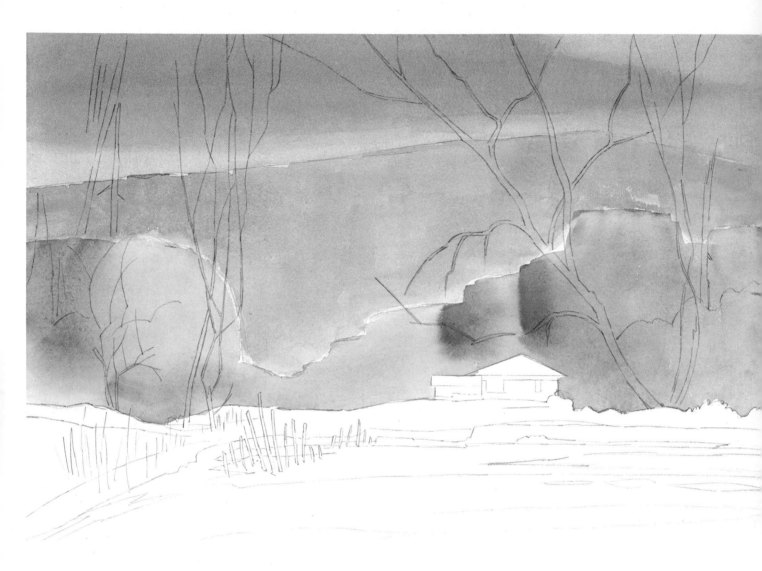

Step Two: With the board still wet, Rossi brushes in the distant hill with Payne's gray. Next he selects burnt sienna for the underwash of the foliage, applying the color wet-in-wet and brushing it in unevenly.

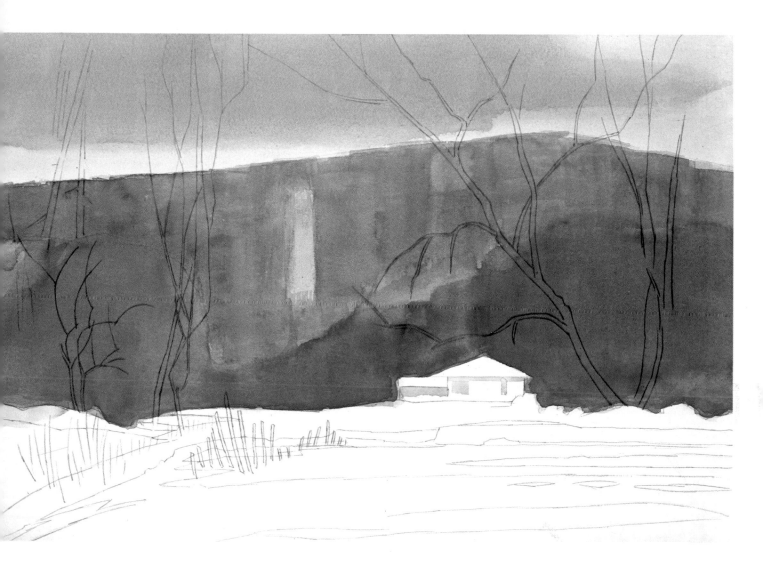

Step Three: Now Rossi further develops the hill and background trees. For these areas he uses mixtures of Payne's gray, burnt sienna, and burnt umber. Even though the underlying washes differentiate these areas, the passages unify the broad areas of color. Next Rossi adds gray shadows to the white house. He has used only his 1½" red sable, flat, square-edge lettering brush to apply paint in the large areas.

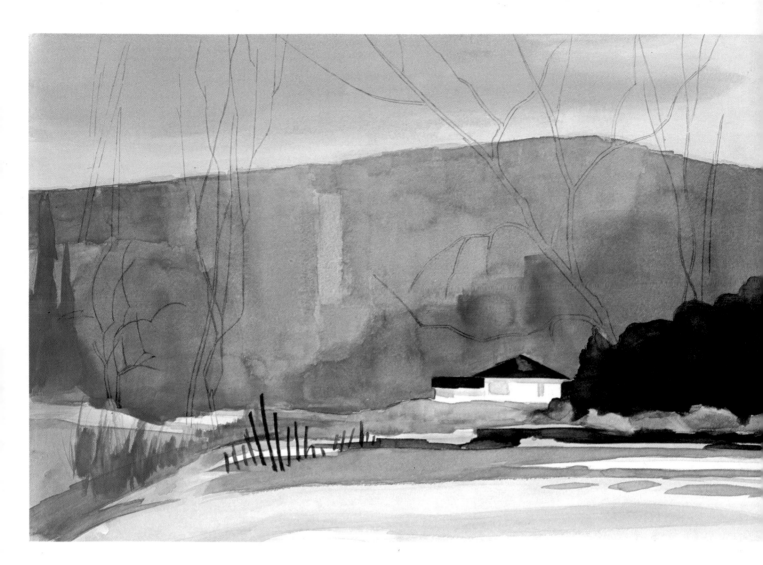

Step Four: Rossi then moves to the roof, the dark trees, the snow covered lake, the ground, and fence. To paint these areas, he selects mixtures of yellow ochre, Payne's gray, and burnt sienna. For these smaller details Rossi uses number 3 and number 7 red sable, square-edge lettering brushes.

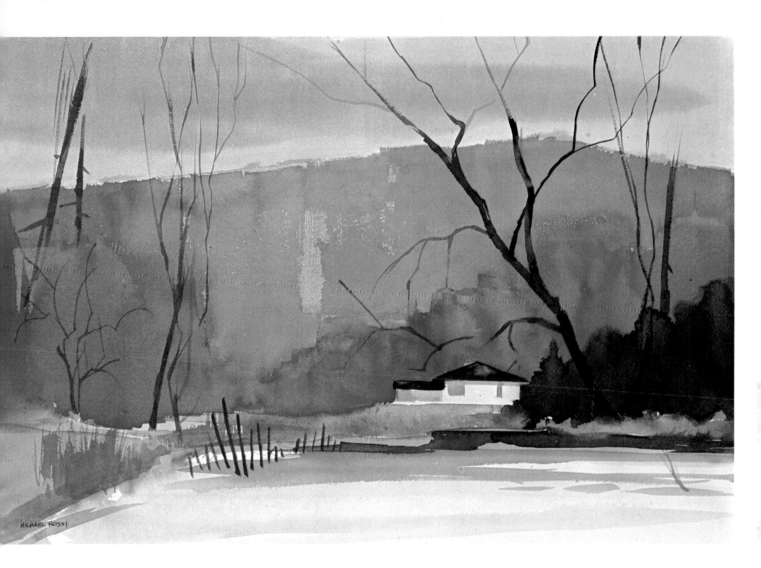

Step Five: Douglaston, 15″ x 22″. While the board is still damp, Rossi softens the edges of the foliage. After waiting for the board to dry thoroughly, he paints the bare trees with a mixture of Payne's gray, burnt umber, and alizarin crimson, again using his number 3 and number 7 red sable, square-edge lettering brushes. The painting is complete. His limited palette has produced a subtle landscape, a study in grays.

Joseph L. C. Santoro

Joseph Santoro is most concerned with making a direct, forceful statement in large areas of bold color and value. Building up large passages of color, layer upon layer, Santoro uses contrasting values to render a bold and simple composition.

Santoro's palette of tube colors includes cadmium yellow light, raw sienna, cadmium yellow, cadmium orange, cadmium red ochre deep, alizarin crimson, Indian red, burnt sienna, burnt umber, raw umber, cerulean blue, cobalt blue, French ultramarine, Hooker's green deep, Winsor blue, and Payne's gray. His brushes are pointed sables numbers 3, 5, 7, 9, 16, and flat brushes in ½", 1", 1½", and 2". He favors a full sheet Arches 300 lb. medium and a half sheet or smaller Arches 140 lb. medium. For outdoor painting he uses a light collapsible easel and at home a 30" x 40" drawing table.

When painting out of doors, Santoro spends considerable time studying his subject from many angles. Although he realizes that he will make changes in his thinking as the painting progresses, he at least attempts to form a definite goal in his painting. He attaches his paper to a lightweight board made of Homosote by stapling the sheet rather than stretching it, so that he can utilize the paper right to the very edge. (Since the Homosote board is porous, the staples are very easily removed.)

Santoro starts by roughly sketching in the composition, thinking in terms of an abstract design, the actual subject matter being of secondary importance at the outset. He looks for large areas that can be boldly reduced to massive washes, but he does not isolate or mask out an area by painting around it. Instead, he prefers to use a broad, free stroke with a very large brush, returning later to add detail over the original wash. If necessary, he will sponge out an area into which detail is to be placed. In his attempt to simplify his painting at this stage, he tends to use one value for the foreground, another for the middle ground, and a third for the background. He may spot a massive dark value in full strength in the foreground to set the key for his entire picture. He places plane against plane and light against dark, moving swiftly. Since he is concerned with pure, forceful painting, Santoro strives to keep his color fresh, rarely mixing more than two colors at a time to arrive at a given tone.

Sometimes Santoro finds it useful to lay in an underpainting. Large rocks, with their varying color combinations from darks to lights, for example, demand the mixture of countless colors, applications of which are built up to the final brush strokes. Thrashing surf, on the other hand, calls for broad sweeping strokes of the brush well-loaded with color. Later, after studying the painting, Santoro may wash out an area with a sponge, and if necessary, resort to bristle brushes, steel wool pad, or even sandpaper, to remove the pigment.

Santoro paints on a wet or dry surface, depending largely on the subject and the effect he wishes to achieve. For example, if the painting includes a large sky area, he wets this thoroughly, allowing the colors to blend readily to avoid sharp delineations which would bring the sky areas into the foreground. There are also times when he prefers to do certain areas in damp, broad washes as underpainting. A dampened surface permits glazing, but it does not muddy the additional colors. Since color painted on a wet surface generally dries to a lighter value, he tries to have the values well established in his mind before soaking that section of the paper. (The more water used, of course, the less brilliant the color will be when it dries.) Certain colors have staining qualities, and he uses these with caution, knowing that they are difficult to wipe out or reduce in value when applied in full strength on a dry surface. Santoro always waits until the painting is dry before he adds details.

When painting outdoors, Santoro tries to complete his watercolor in one sitting. When he returns to the studio, he mats the painting, studying it further and making whatever changes he feels necessary. For a studio painting, he works much more slowly, sometimes over a period of days.

Step One: Santoro makes a quick pencil sketch directly on his paper, Arches 300 lb. medium surface, to indicate only the major wash areas. He enjoys painting woodland scenes because of their familiarity. As a youngster he did a good deal of hunting, and the woods always remind him of happy moments spent there.

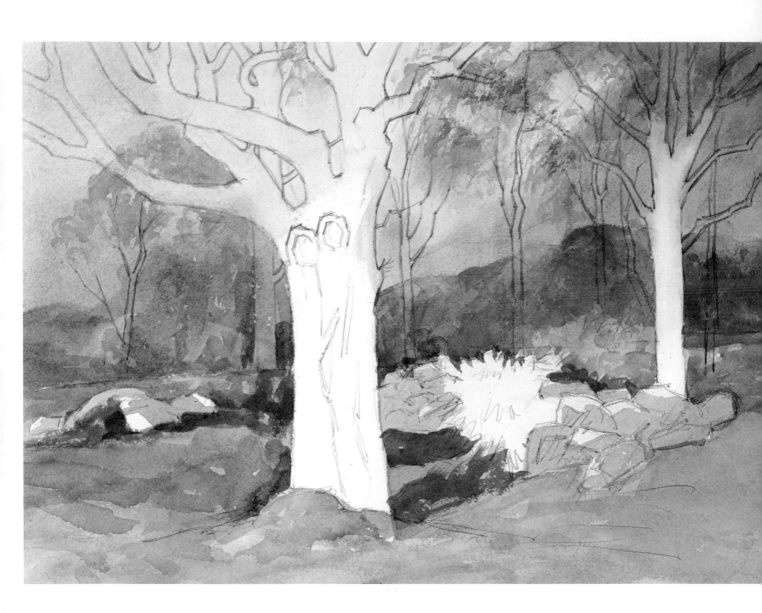

Step Two: Santoro lays in the large washes, selecting the colors and values that will approximate the final effects desired. Only in the sky area does Santoro wet his paper. In the wet paper the color edges fuse, a means of keeping the sky in perspective. He paints right over the trees that appear against the sky rather than attempting to paint around them. He lifts off color whenever necessary: note the tree at right, for example. Then Santoro lays in the distant mountains over the washed-in sky and next the foreground. Although Santoro usually paints from light to dark, in this picture he establishes a few of the dark tones, the shadows, for example, as soon as possible to give him an idea of the full range of values.

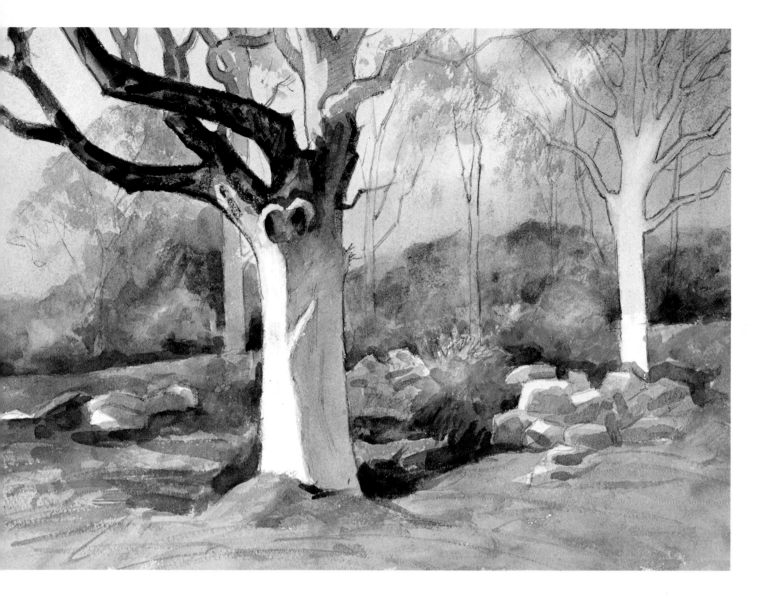

Step Three: Santoro paints the darkest dark in the foreground tree branches and the middle values—the reddish bush, the shadow side of the big tree, and the shaded areas of the rocks. At the same time he suggests the textures and indicates the details.

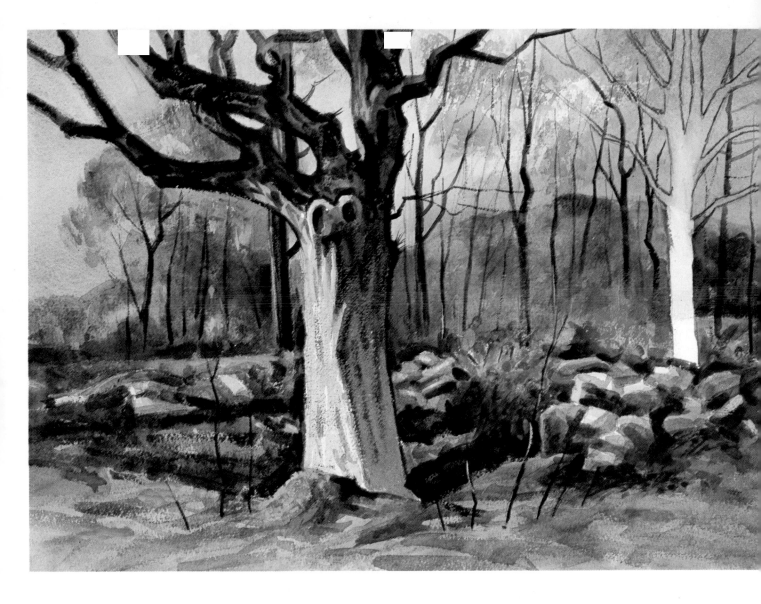

Step Four: At this point Santoro begins to pull the painting together. He strengthens some values in the tree, rocks, and bush, for example. He uses dark accents to unify the composition (the slender tree trunk in the background, the twigs in the foreground). To create textures he drags the bristles along the back for a dry brush effect.

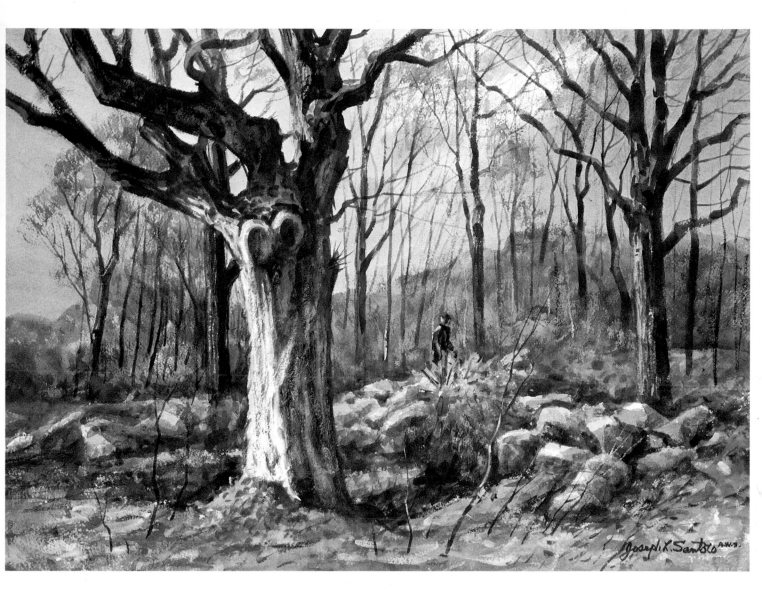

Step Five: The Lone Hunter, 22″ x 30″. In the final stage, Santoro completes the details and softens many edges. He paints the hunter and completes the tree at the far right. In some areas of the painting Santoro picks out highlights by rubbing a typing eraser over the dried areas. In other passages where he wants highlights, Santoro paints over the area with clear water, then scrapes out pigment with the handle of his brush which he has cut to a point with a pen knife.

Millard Sheets

Millard Sheets believes that design is a fundamental means of organizing feelings and thoughts within the limits of the paper. According to his view, nothing can be achieved in oil or other opaque media that cannot be obtained in transparent watercolor, providing the artist overcomes his hesitance to work into a value either wet or dry with overwashes. Believing that transparent watercolor is unlimited as a painting medium, Sheets asserts that a single wash technique limits the full range of values and color possible with watercolor. He maintains this point of view in spite of the fact that he personally enjoys the clear, once-over washes.

Working with a fairly limited palette—cadmium yellow, cadmium orange, cadmium red, ultramarine blue, cobalt blue, raw sienna, burnt sienna, and monastral green and blue—Millard Sheets achieves the full range of values and intensity equal to oils or acrylics. His selection of tools is equally minimal: round sables numbers 14 and 18; Japanese flat brushes, 1″ to 4″ wide; 1″ flat sable; ½″ flat bristle brush; and ¼″ round bristle brush. He uses no additional materials, and always paints on Arches 300 lb. medium rough paper.

Sheets prefers to work from a fragmentary pen sketch (made, perhaps, years earlier), interpreting it freely so that he is not trapped just by what his eye has seen. He establishes the basic values and color harmonies of his painting in the first thirty minutes. Greater depth of detail and deeper establishment of character can be added immediately or weeks later.

Sheets has no set procedure for working. He may complete his painting totally outdoors or in the studio, or work totally from memory or from a rough pen sketch. He may add details on a wet or on a dry surface, concentrating only on what he wants to achieve in the end.

When he works in the studio, Sheets paints at a drawing table that tilts from vertical to horizontal. When he goes on location, he carries a box that holds his palette and drawing board, and he sits on the cover of the box while he paints.

He always carries a mat, and if possible, a frame (when he goes on extended painting trips) to check his composition while a painting is in progress.

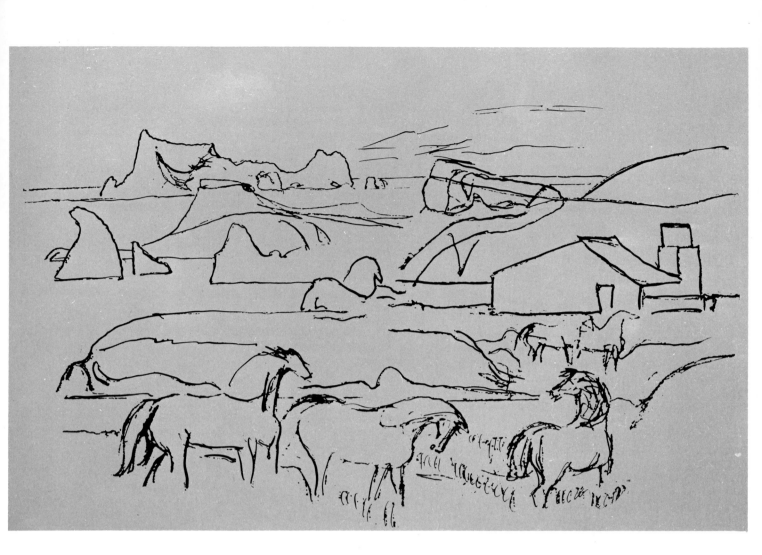

Step One: Millard Sheets has a particular affection for northern California, and this is reflected in his work. Using an imagined scene derived from his observations of the northern California landscape, Sheets makes this pen and ink sketch directly on the paper. The sketch establishes the design; the forms of horses are echoed by the rocks in the background.

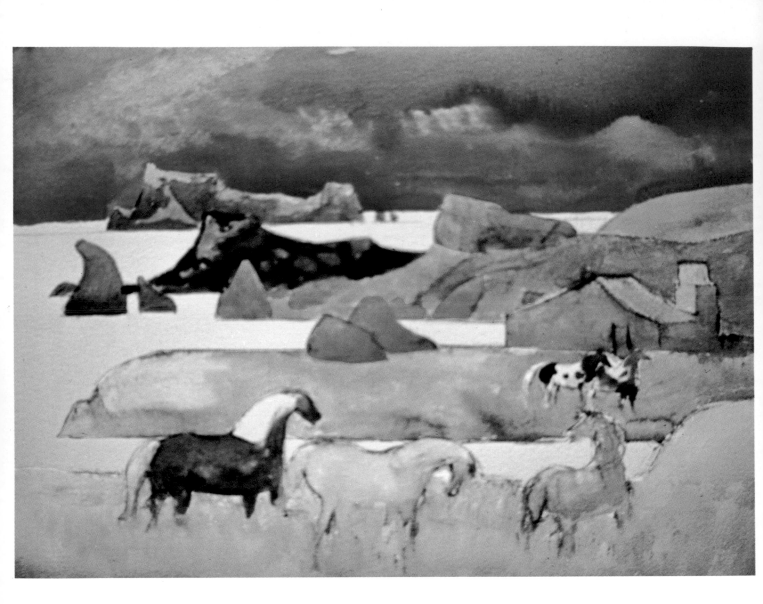

Step Two: Within the first half hour Sheets establishes the basic color harmonies throughout the composition. First he lays in the sky wet-in-wet and suggests the distant mountain range with a second wash. Because his palette is fairly limited, he places his colors so that variations of the same mixtures are repeated in several passages. Sheets regards this first stage as a preliminary underpainting, knowing that colors and shapes can be altered with subsequent applications of paint.

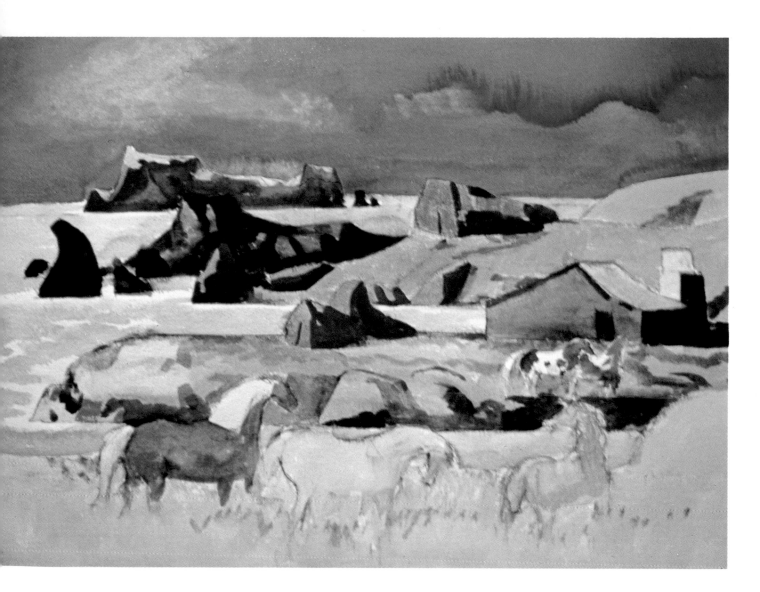

Step Three: Now that Sheets has established the flat masses of color, he introduces the direction of light (coming from the left in this case). This light creates a feeling of depth as it sweeps across the forms, producing highlights in some passages and shadows in others. The rocks begin to assume shape, and the house is solidified. Now Sheets can indicate the darker values in these areas. A light application of color is made on the water that weaves in and out of the composition.

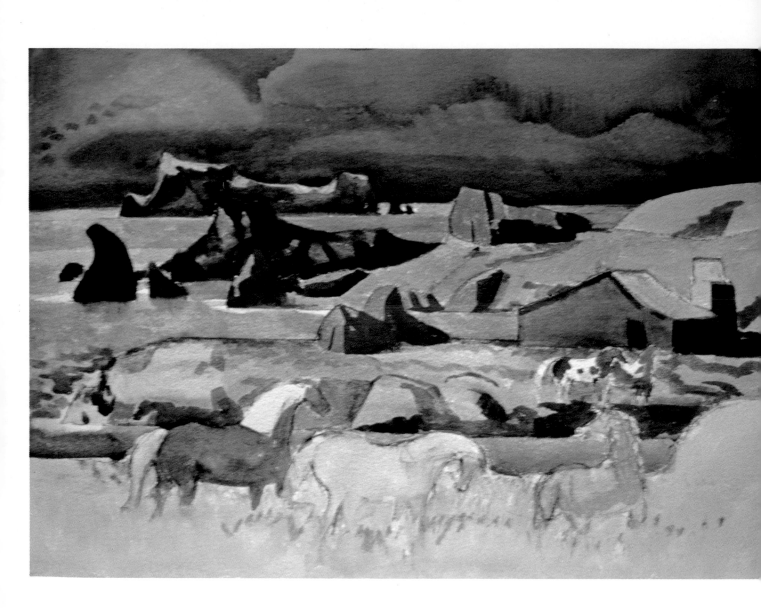

Step Four: The water is developed further so that it ties the composition together. Now the silhouettes of the horses emerge against the strip of water. Next Sheets moistens his paper and develops the sky area further.

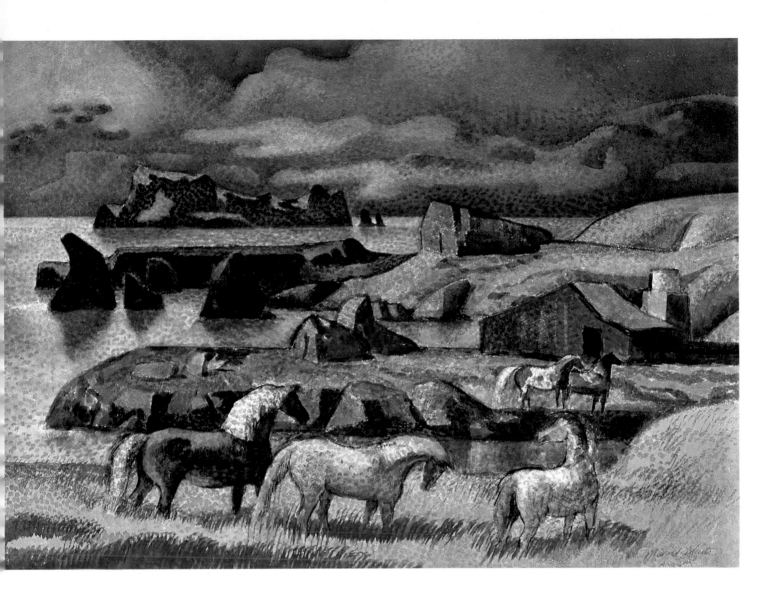

Step Five: Mendocino Coast, 21″ x 29″. In the last stage Sheets really goes to work: he builds up his colors much further and changes the character of the painting almost entirely. The shapes are abstracted even more so that they become planes of color. The values are brought more closely together: the roof of the house is darkened, the water and rocks are no longer in contrast, and the distant rocks merge into the sky. The shadows on the grass strengthen the foreground. As a final step, Sheets dips the point of his sable brush into the pigment and stipples the entire surface of his composition. This tones down the lightest values and pulls together the entire painting, creating an even more abstract quality.

William Strosahl

Whether Bill Strosahl works in watercolor or in acrylics, his palette is always the same: cadmium yellow, yellow ochre, cadmium orange, cadmium red, alizarin crimson, ultramarine blue, Prussian blue, phthalocyanine blue, Payne's gray, Van Dyck brown, burnt umber, Winsor green, Hooker's green, and Davy's gray. Occasionally, for a special purpose, he adds cobalt violet and burnt sienna to this list. Not all these colors are used in any one painting; generally he uses seven or eight, and at times only four.

Strosahl's approach toward a given painting is dominated largely by the design elements in the composition; he attempts to take a common subject and express it in an uncommon way. Sometimes his paintings are rather objective. At other times the subject and mood are better expressed in a more abstract fashion.

For outdoor sketching, Strosahl generally uses a French easel, sturdy and portable, that contains a drawer for paints and brushes. He keeps his water in a Prince Albert tobacco tin which hangs onto the drawer of his easel by an angle iron he has attached to the tin.

In the studio, where Strosahl does most of his work, he paints at a draftsman's table. His paper is stapled to a sheet of ¾" plywood and placed on the table. (The plywood measures 34" x 26", about 6" smaller than the top of the drawing table.)

Arches 300 lb. cold-pressed paper is Strosahl's preferred choice, but he has been using Capri paper in the same weight as well. He finds it unnecessary to stretch either of these papers and sometimes does not even bother to staple the paper to the plywood. Recently Strosahl has returned to Multimedia board for thin acrylic washes. This board is especially desirable if he intends to include a collage in the painting.

Strosahl's brushes include red sable rounds, numbers 12 and 8; red sable flat aquarelle, 1" and ½"; and a 2" housepainter's sash brush. For acrylics he also includes nylon flat brushes in 1½" and ½" widths. For scraping the surface, Strosahl uses a razor blade, mat knife, or frisket knife. To hasten the drying time of a big wash, he relies on a hairdryer. The edge of a credit card dipped in color or a ½" Speedball steel brush pen are the two items he selects for creating line accents in his paintings. In fact, he sometimes begins a painting by making an outline drawing on his paper with the steel brush.

Generally Strosahl works from sketches he has made on the spot. If details are a necessary aspect of his subject, he refers to snapshots he has taken as well. He reworks these sketches and photographs in the studio, concentrating on composition and simplifying the light and dark areas. If the subject is complex, Strosahl makes a detailed drawing in pencil or pen. A simpler subject requires only that he block in the bigger areas. Then he transfers the small sketch to his paper with a modified squaring-up method using only six squares.

As he begins to paint, Strosahl usually attacks the area that will give him the most trouble, perhaps a cloud-filled sky or a house in the foreground. Regardless of where he starts, he works from light to dark.

The sky is generally painted wet-in-wet and the foreground handled in a much dryer manner, but there is no set procedure. Strosahl adds details when the surface is dry or nearly dry. He always attempts to complete a watercolor in one session but often makes corrections or additions after studying the painting a few days later.

Since he works in only full-sheet or half-sheet sizes, Strosahl needs just two mats to help visualize the final effect, and he does this three or four times during the progress of the painting. When he feels the watercolor is complete, he tacks the matted painting to the wall for judgment. He loses quite a few paintings with this method: a week later a painting may not have the same spirit he thought he had captured while painting it.

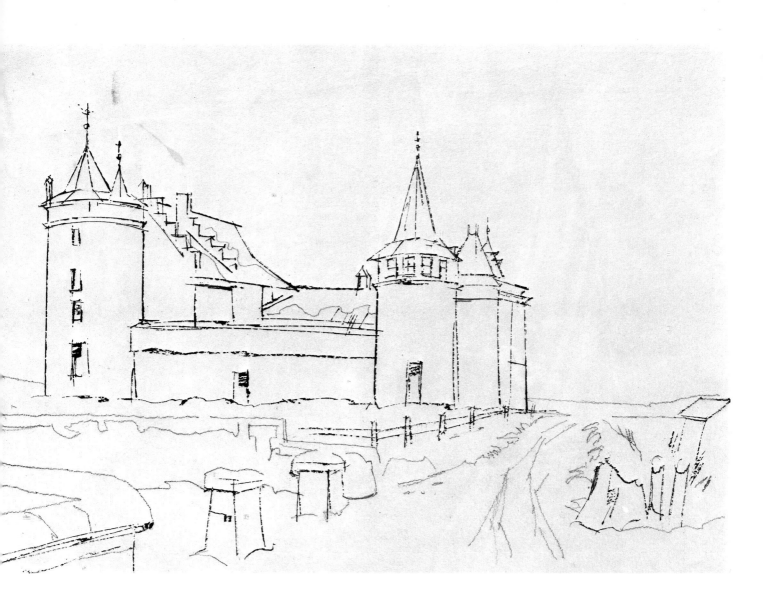

Step One: On a 27½ ″ x 20″ surface, Strosahl makes his drawing. He uses a steel brush pen and India ink to indicate the hard or sharp edges, angling the pen to obtain fine lines. The steel brush pen is particularly useful for straight lines, such as those found in architectural subjects, and the artist does not need to rely upon a ruler. The pencil marks on the paper indicate the areas requiring a softer or lighter treatment, such as the shadows falling on the snow.

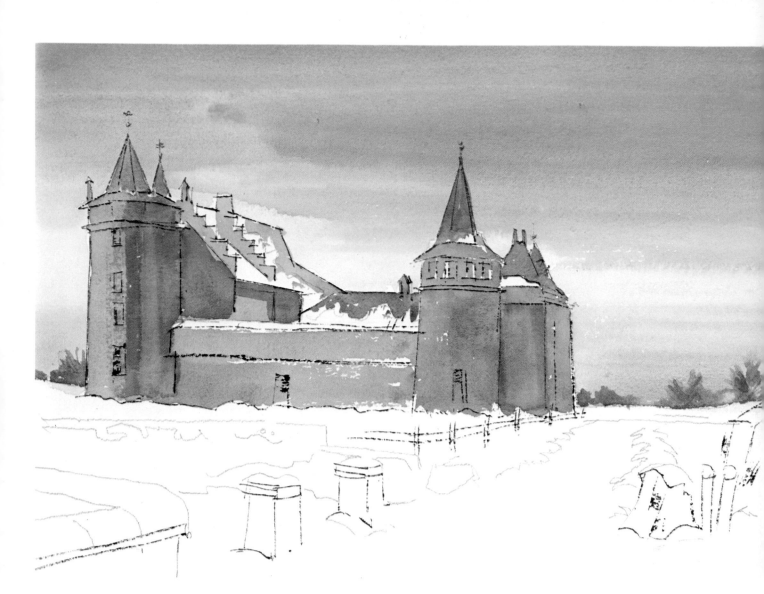

Step Two: Strosahl's palette is limited here to phthalocyanine blue, burnt umber, Van Dyck brown, and Davy's gray. Using only four colors, the artist automatically achieves a unity of color. First he floats in the sky on a wet surface, grading the wash so that the pigment is heavier at the top of the sheet and flows to a neutral color at the horizon. Strosahl blocks in the towers next, knowing he will darken them later. While the sky is still slightly damp, he indicates the small distant trees on the horizon. Then the local ground color of the castle is painted in burnt umber. This, too, will be darkened later, but the underlying color will provide the basis for color unity in the structure.

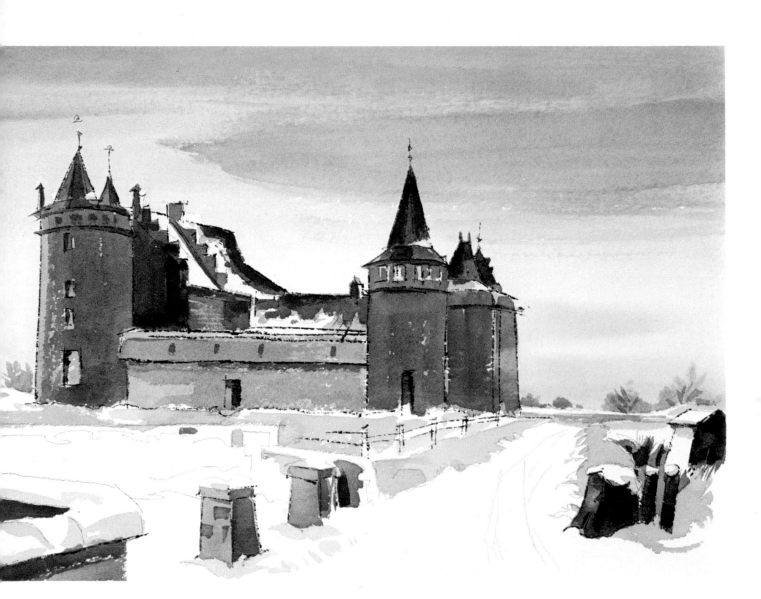

Step Three: Next Strosahl models the towers and turrets, using a mixture of phthalocyanine blue and burnt umber. He obtains three values by varying the amount of burnt umber placed in the phthalocyanine blue: the lightest value is dragged over the front portion of the castle, the middle value on the towers, and the deepest value in the turrets and in the deep shadow areas of the building. When these applications are dry, he paints the lighter snow areas with a highly diluted phthalocyanine blue. Next he moves to the dark areas in the foreground to indicate the posts and tree stumps.

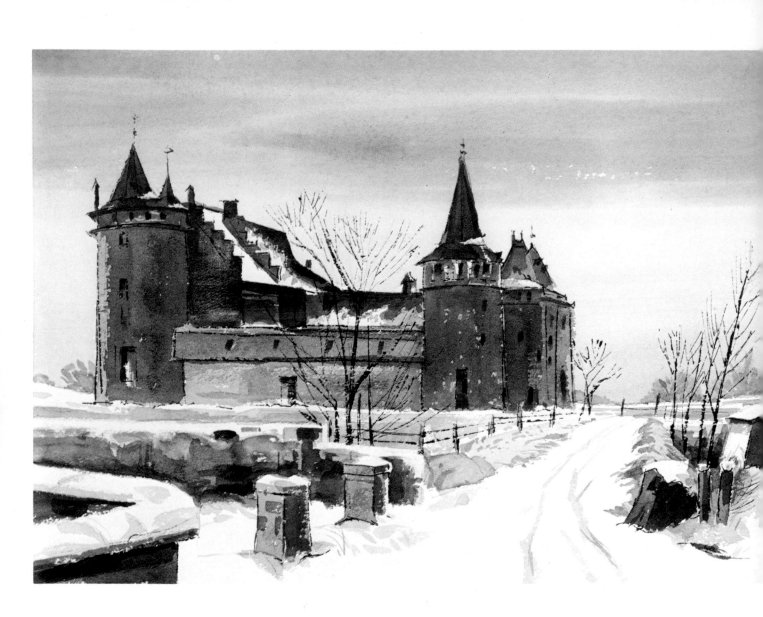

Step Four: Strosahl provides cohesion for the painting with blue, combining it in mixtures with other colors and placing it throughout the sheet: darker snow values are indicated and the ruts in the road snap into place. Using a razor blade, Strosahl picks out the snow on the roofs and softens the edges. He uses the steel brush to draw in the bare trees and to sharpen up the fence, the windows in the towers, and small accents here and there.

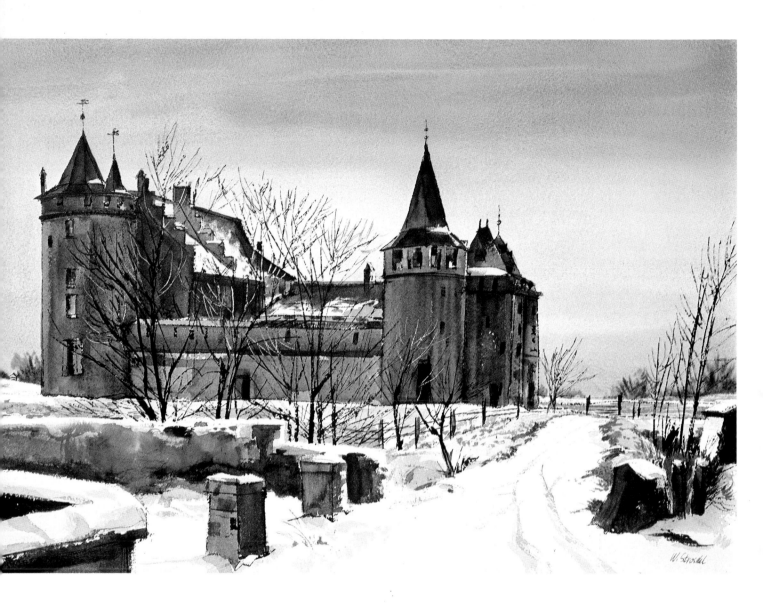

Step Five: Muiden Castle, 27½″ x 20″. Continuing his work with the steel brush, Strosahl increases the number of bare trees in the middle ground, continuing his strokes into the sky area. With his razor blade, Strosahl scratches out some of the darks in the castle so that the snow-covered branches stand out against the building. There is now a contrast between the massive structure of the castle and the delicate, wispy lines of the barren trees.

Donald Teague

Donald Teague is particularly fascinated by subject matter dealing with foreign countries in general, and Spain in particular. His dramatic watercolors reveal his enthusiasm for this subject, and the methods he employs are designed to project that enthusiasm. Details are a very important ingredient in his painting, and for this reason he does not generally complete a painting on the spot. Instead he makes shorthand notes in color and in writing, and supplements this with color photographs.

In his studio Teague begins with a carefully detailed drawing which he has derived from a final sketch made from material accumulated on the spot. First he puts in the darkest accents, then the sky, middle ground, and foreground—in that order—attempting to complete each area while it is still slightly damp.

The small details are generally put in the next day, on dry paper, but the overall effect of the picture is usually complete by the end of the first eight or nine hours. Teague tries to finish every painting with no interruptions, aside from eating and sleeping, in a two or three day run.

For sketching outdoors, Teague uses Winsor & Newton sables, series 7 in numbers 6 and 10, and works on Strathmore Alexis pads, 6″ x 8″ or 8″ x 10″, held in his hand. His palette for sketching includes only a few colors: cadmium lemon, yellow ochre, alizarin crimson, raw or burnt sienna, Winsor green, cobalt blue, and lamp black.

Working in the studio, Teague uses a wider range of materials, though by no means extensive. In addition to the colors he uses for sketching on location, he also includes cadmium red orange, Hooker's green deep, Payne's gray, and indigo. His assortment of brushes includes Winsor & Newton sables numbers 10, 11, and 12; 1″ Grumbacher's flat sable; 1″ Rubens flat bristle; housepainter's nylon brush; and a 1″ sash brush. Additional materials which see occasional use include a knife, razor blade, soap, paper towels, hairdryer, liquid frisket, and diaper cloth.

Teague paints at a drawing table with a 31″ x 42″ top that raises and lowers and is adjustable to all angles from horizontal to vertical. On his table he places his paper, a Green's 300 lb. or 400 lb. cold-pressed sheet. He usually soaks his paper thoroughly and puts it between two heavy pieces of chipboard overnight. The following morning, while the paper is still slightly damp, he staples it to a heavy drawing board.

Teague occasionally uses a trial mat while the painting is in progress, but he more often prefers to place the intended frame directly on the painting.

Step One: This pen and ink drawing represents the final composition of Teague's watercolor, a synthesis of approximately twenty-five to thirty sketches that preceded it. All Teague's preliminary drawings are nearly the same size as the finished painting. This drawing is photographed on 35mm film and projected onto the watercolor paper.

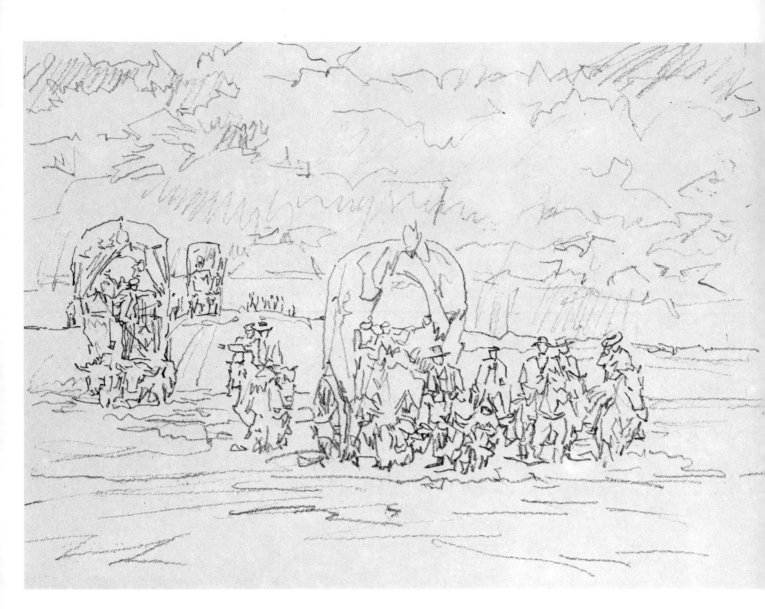

Step Two: Teague traces over the lines of his projected pen and ink drawing. In doing so, Teague leaves open areas to indicate where the washes will be applied. No attempt is made to suggest values or tonality. This drawing is simply to break up the areas of volume and color for an unusually complex arrangement.

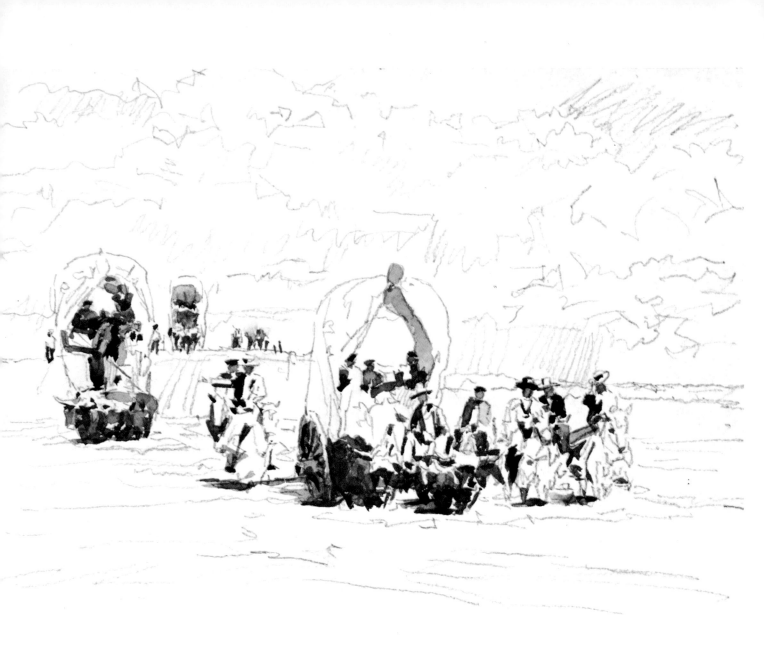

Step Three: Unlike most watercolorists, Teague does not necessarily begin by painting the sky. He is more concerned with setting the color key for the painting at the outset. Here Teague establishes the full range of values. First he puts in the darks and then works toward the light values. Although the painted areas are small, Teague has actually indicated a complete keyboard of colors between the white paper and the deepest tone.

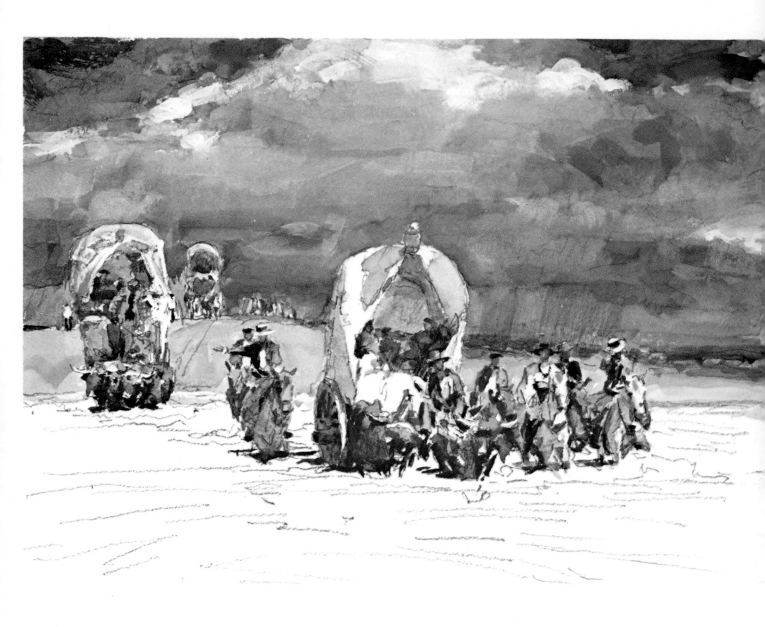

Step Four: After the extremes of values have been established, Teague has little difficulty in determining his middle value—the sky. In this area he lays in various mixtures of blues and grays and waits for this to dry. Then he adds small amounts of opaque white for the clouds and covered wagons. Next he adds a neutral tone for the land area. Once these have been established, Teague further develops the figures and animals in the foreground.

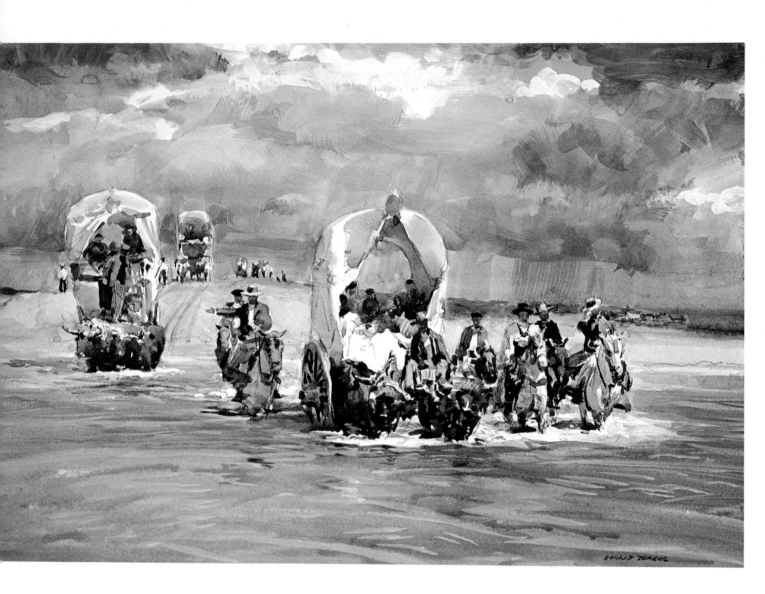

Step Five: Spanish Holiday, 10″ x 14″. Since the water is very close in value to the sky, the color scheme is extremely simple and only a minimal number of details are required to complete the painting. Saving the white of the paper for the areas of the water around the horses' legs, Teague lays in an underwash, waits for this to dry, then skims over the surface with his brush, leaving streaks of pigment to suggest the movement in the water. He finally tightens the foreground and distance—the elements on the horizon—and the painting is complete.

Eileen Monaghan Whitaker

Working from notes, Eileen Monaghan Whitaker does all her painting in the studio. Her pencil or ballpoint pen sketches—fragmentary or carefully detailed—are made whenever a subject excites her imagination. When she begins a painting, she lays out the composition in pencil, a detailed drawing in the case of figures, animals, and architectural subjects but otherwise quite loose.

She paints standing at a large adjustable drawing table on which she has placed her unstretched 22″ x 30″ sheet. (Arches 300 lb. cold-pressed paper or Fabriano 300 lb. hot-pressed paper.) She starts with the center of interest, one figure perhaps, working back and forth between it and the surrounding areas to establish the key for the rest of the picture. Drawing in color with a brush is part of her usual procedure. She usually starts to paint the darkest areas first, which are often the part of the background surrounding the center of interest or the lightest area. Except when conditions call for a large, extended wash, she prefers to work on a dry surface.

Eileen Whitaker often adds details to a painting while the surface is damp, depending on the subject and the desired effect. The fact that she does not try to complete a watercolor in one sitting means that she has several pictures in progress at the same time, and sometimes a month will elapse before she completes one. (As long as a painting remains in her possession, she is never really finished with it, for she regularly takes out her paintings and reworks them.)

Her palette of tube colors includes cadmium lemon, cadmium yellow deep, raw sienna, raw umber, Winsor blue, Winsor green, emerald green, permanent green light, burnt umber, Indian red, sepia, cadmium scarlet, cadmium red, Winsor red, cobalt blue, and cerulean blue—although she normally uses only about half of these in any one painting. Her brushes are mostly flat ox hair or sabeline brushes, from ½″ to 1½″, and also a round, double-ended Japanese brush. Occasionally she uses a few round, red sable brushes numbers 8, 14, and 30. Although she resorts to other materials, such as knives, sponges, and cotton rags for color removal, she strongly opposes using rubber cement or Maskoid for blocking out areas.

Step One: First Eileen Whitaker conceives her idea on a small scale (anywhere from 2″ x 3″ to 5″ x 7″), working out a variety of thumbnail drawings in pencil until she arrives at what she feels will be an interesting painting. The theme she selected for this painting is Chac Mool, a Mexican god. This stone figure is seen in many areas of Mexico, always portrayed in the same pose. The artist makes an accurate drawing from the sculpture and uses this to work out a composition combining the Mexican god with abstract shapes. After selecting her thumbnail sketch, she develops another drawing to define and rearrange shapes and values in pencil.

Step Two: After developing her concept of shapes and values in her drawings, she makes a full-scale drawing on a 22″ x 30″ sheet of watercolor paper. This drawing is merely a light indication of shapes and shadow patterns. She will continue to use her earlier drawings for reference.

Step Three: Eileen Whitaker gives her first consideration to the center of interest, the head of Chac Mool. From there she moves to other areas, working only enough to establish the key to the entire composition and avoiding any temptation to get carried away with details. She applies light washes of color, giving little attention to values at this stage. These will be corrected and developed later.

Step Four: This is always the most exciting stage of painting for the artist, working one area against another, playing with color, rhythm, and texture, and solidifying values. She moves throughout the painting, bringing along each area at the same time as she works on a damp surface. Both linear effects and dashes of color are applied at this point, as she works rapidly until "the fire has burned." Then she stops painting and ignores the watercolor for several days to gain a fresh outlook.

Step Five: Chac Mool #3, 22″ x 30″. The final stage of painting normally requires very little pulling together. In this painting, however, the work develops rather slowly. A great deal of drybrush seems appropriate. Moreover, the artist uses an extensive spatter of color to carry out the mood, a romantic, imaginary atmosphere for the mysterious Mexican god.

Frederic Whitaker

It's been said that Fred Whitaker "can paint anything." The diversity of his subject matter, color combinations, and compositional arrangements makes him an extraordinarily versatile painter. Unlike many artists, who make a lifelong practice of depicting a small number of subjects, Whitaker paints anything under the sun that strikes him as good picture material.

When working outdoors, Whitaker usually begins by making a very small pencil sketch on a piece of paper, adding the outer borders after the general sketch has been completed. The sketch is carried only far enough to show him definitely the arrangement of the compositional parts on his full sheet. Then the scene is drawn, in pencil, on the watercolor paper, loosely for vague or impressionistic subjects or quite carefully for architectural or other closely detailed work.

Occasionally Whitaker works on moist paper, but generally he starts to paint directly on dry. In applying the paint, Whitaker covers the paper quickly so that he can see the entire scene in a general way, perhaps omitting the sky, which is usually painted last. He seldom copies nature literally and finds it easier to key the sky to the rest of the landscape than the reverse.

In covering the paper with color, Whitaker does not try to match any particular hues or values. These can easily be developed later. He may, for example, simply brush in a medium green wash to cover all trees and grass; pale raw umber for bare earth; red for a barn. Then, section by section, he brings the various picture components to advanced stages of completion. The sequence is determined by the subject itself. Later he pulls the whole painting together by correcting the relative values and colors.

When working in the studio, Whitaker follows very much the same procedure as he does outdoors, except that he works from a much more carefully detailed, small color sketch, a sketch often derived from notes that he made on location or from his imagination.

Nearly all Whitaker's painting is done with square-ended, flat ox hair brushes, which range in width from ¼″ to 1½″. He uses an inexpensive, double-ended Japanese brush in a bamboo handle for line drawing or fine detail. (There are two brushes of different sizes at each end of the handle, and he finds them fully equal to the expensive sables.)

His palette of tube colors includes ivory black, sepia, burnt umber, yellow ochre, cadmium yellow light, cadmium orange, cadmium scarlet, cadmium red, Winsor red, cobalt violet, phthalocyanine blue, permanent green light, Winsor green, oxide of chromium, viridian, phthalocyanine green, raw umber, cerulean blue, and cobalt blue. He leans heavily on the sepia, using it in place of black.

Indoors Whitaker sits before a table 20″ x 40″ and 18″ high. A drawing board rests on the table with the top end of the board raised somewhat and balanced in such a way that he can raise or lower the angle of the board at will. At his right and left are two long benches, each also 18″ high. The bench at the right holds his colors and tools, while the one at the left holds other more inactive supplies.

Although Whitaker occasionally alters his paper to suit an unusual problem, his favorite sheet—used in 90% of his work—is Arches 300 lb. cold-pressed. He does not stretch the paper, but simply clips it to a ¼″ plywood board with large, strong stationary clips. As he works, the paper buckles slightly, but he ignores this. When he completes the painting, he flattens the sheet perfectly by moistening the back. After the loose water has been absorbed, he dries the paper under pressure between pieces of corrugated board. Several days may be required for perfect drying.

After finishing a painting, Whitaker likes to leave it on the floor, matted, so that he can scan it as he goes by. By the end of two or three days any faults will have shown themselves. These are corrected, and the painting then goes through the flattening process.

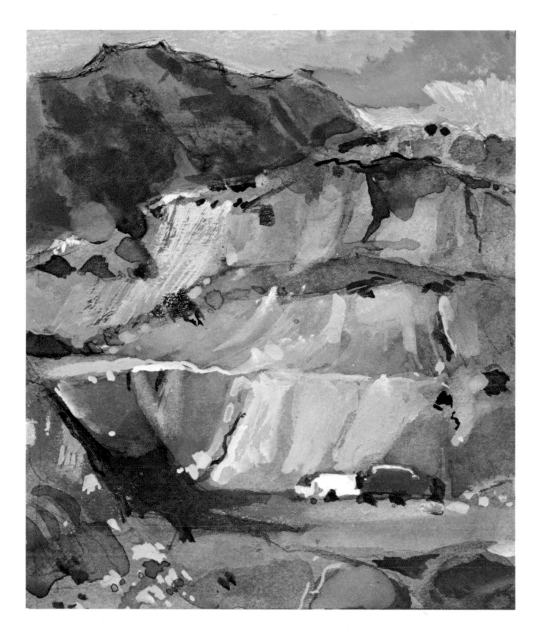

Step One: This small color sketch made in gouache is the design or blueprint for Whitaker's projected painting. In general he spends a relatively long time on this preliminary design stage of his painting because he considers the basic composition the most important part of any work of art. Whitaker starts this color sketch outdoors, on location, but he carefully refines it in the studio. After completing the color sketch, Whitaker knows exactly what he is going to do in his painting, so he follows his pilot sketch closely. The proportions are exactly the same as those of the final painting.

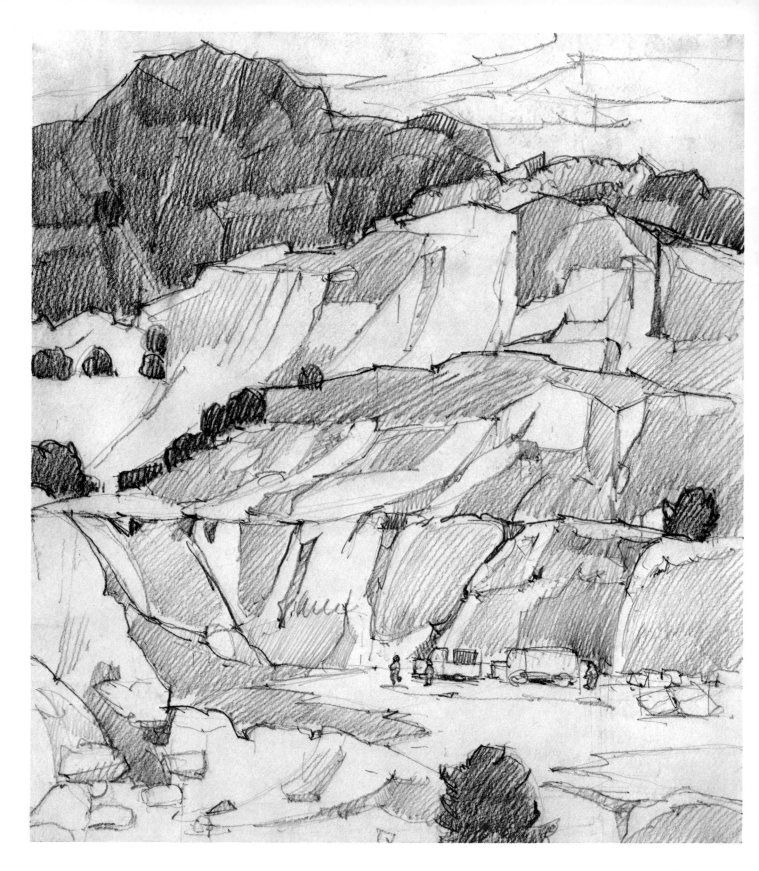

Step Two: The drawing is made full size with a heavy soft pencil. When enlarging the color sketch to the final watercolor sheet, Whitaker uses a pair of dividers to get the exact position of the main elements, then he draws in the intervening details freehand, following his color sketch closely. On some paintings his preliminary drawing on the watercolor sheet is less exacting than this one, but here he felt the shadow pattern was so crucial to the painting that he wanted an exact indication of their placement.

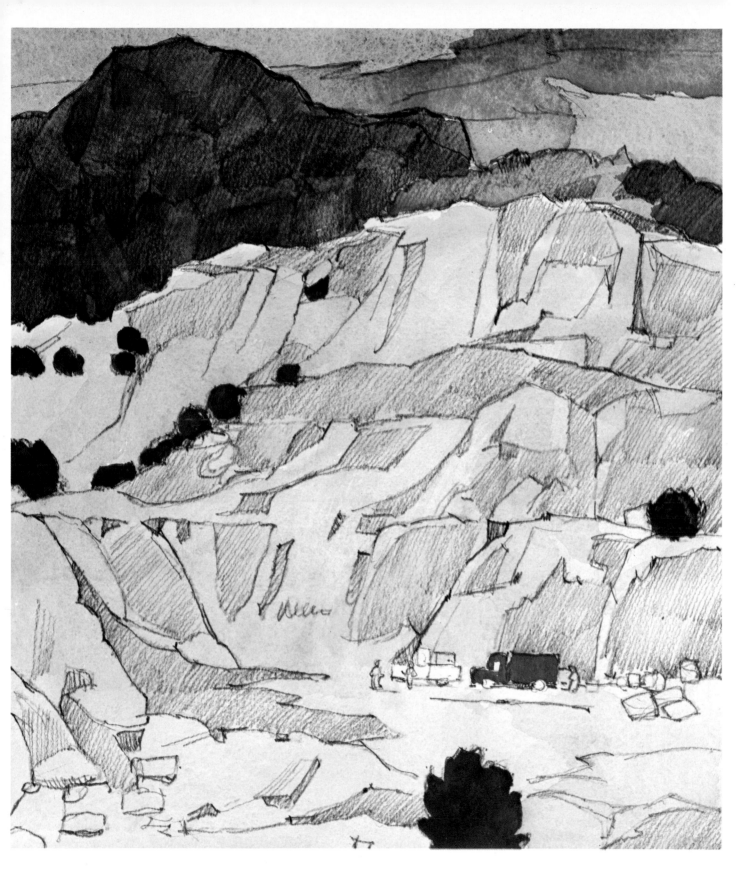

Step Three: In this stage Whitaker is anxious to get his paper completely covered with color so that he can see at a glance what he was working with. He applies flat color over each section: yellow-orange over all the exposed earth, green on the bushes, purple-brown over the distant mountain, and so on. At this stage he is unconcerned with the accurate colors or values, knowing he can easily modify them later. The fact that the pencil lines still show plainly through the color does not trouble him. Pencil lines can be erased through any light wash of color.

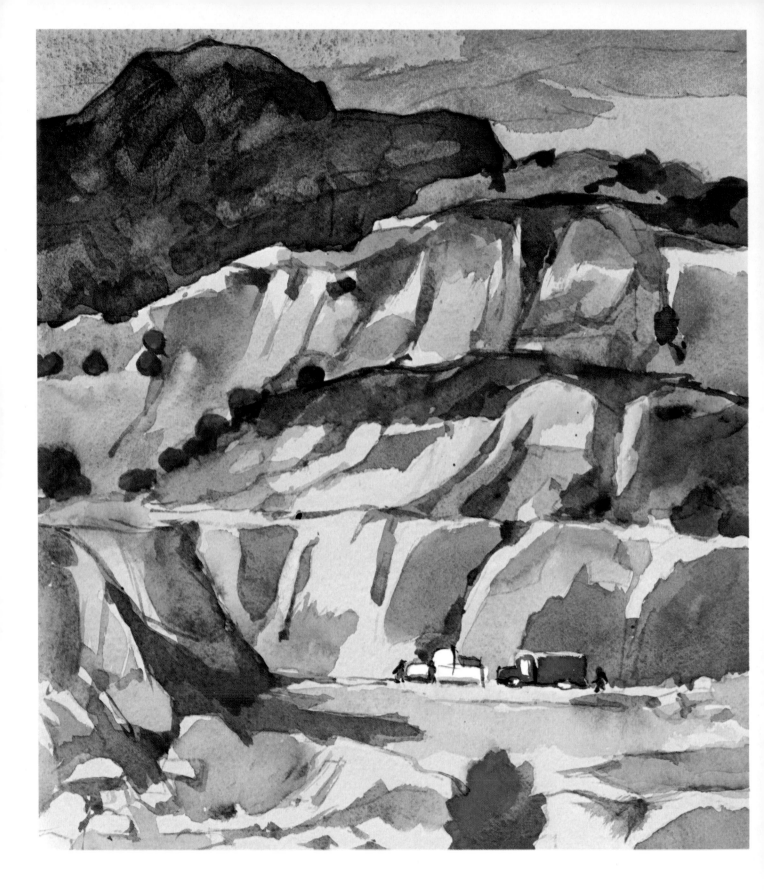

Step Four: Here Whitaker roughly indicates the entire shadow pattern with color. He covers the pencil marks with a deeper orange and erases the marks after the paint has dried. After looking at what he has achieved thus far, Whitaker visualizes the entire painting. He knows that the shadow patterns will have to be lightened in some areas, intensified in others.

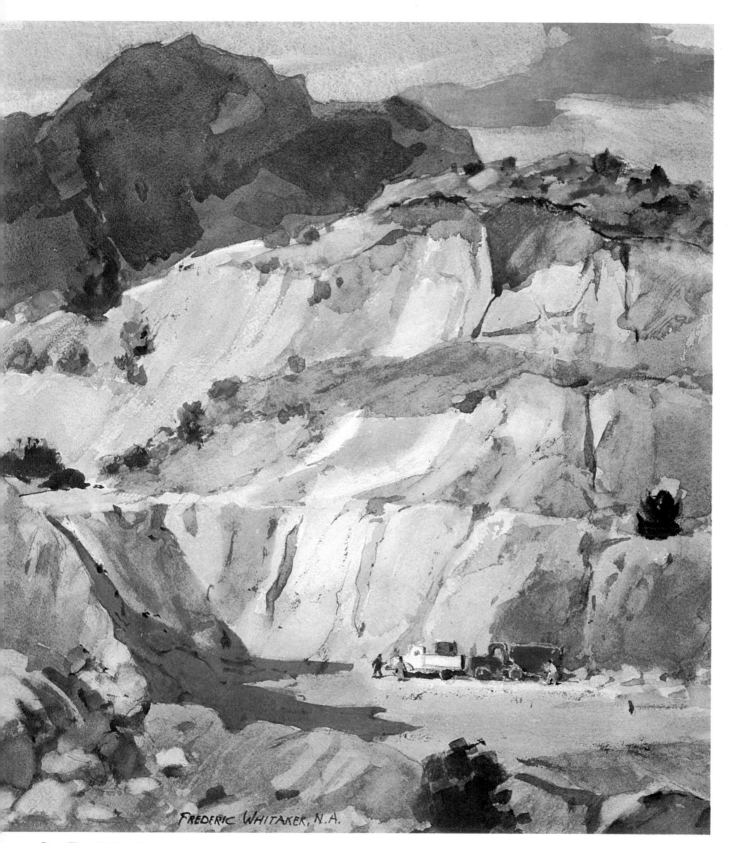

Step Five: Relic of the Comstock Area, 21" x 23½". By mopping out and overpainting, Whitaker introduces accents and highlights. Colors and values are corrected and brought into their proper relationships. Where earlier Whitaker had been casual about color application, at this final stage he qualifies the color carefully. Using a small sable, he completes the details, such as the truck and figures and the textures in the rocks and bushes.

Edgar A. Whitney

"Technical facility is a prerequisite for competence," asserts Edgar Whitney. "Then, after that, I have absolute trust in the principles of design." Whitney is as good as his word: both technical competence and strong design sense are characteristics of his own work.

Whitney paints either from annotated sketches or directly from the subject without making any preliminary drawing. He carefully avoids any fixed procedures, since he feels that the inevitable result of a repeated process is boredom. Whether painting outdoors or in, therefore, Whitney intentionally varies his methods, constantly experimenting. He has been most fortunate with one procedure in particular: first he makes a design on a postcard-size sheet of paper, allocating and relating the lights, darks, and middle tones; then he draws on paper with a pencil, brush, or goose quill and India ink. Next he saturates the paper (if 140 lb.) or wets only the surface (if 300 lb.), drying it partially with a sponge, so that he will have full control of the medium. Then he paints from light to dark, referring to his postcard-size design on which he has determined the patterns.

Indoors, Whitney paints on a drawing board. Outdoors he sits on a folding stool; in front of him is a wooden structure (made of wood interlocking at right angles that collapses and fits into his painting bag) that functions as a small stool, and a support for his paint bag and his paper clipped to a piece of Masonite. To his right is a duplicate of this wooden structure that holds a pan of water, sponges, and his O'Hara palette.

Whitney's selection of colors includes cadmium red light, cadmium orange, cadmium yellow medium, strontium yellow, phthalocyanine green, viridian green, Prussian blue, cobalt blue, ultramarine blue, alizarin crimson, Indian red, burnt sienna, yellow ochre, raw umber, burnt umber, and ivory black. He has a handy brush which he calls the "Whitney Rotary," a number 8 red sable round with a ¾" sabeline flat on the other end (he attaches the two brushes together himself). He also uses a number 6 and number 12 red sable round; a number 6 rigger; a ½" red sable flat; and the brush that he relies on for 75% of his work, a 2" camel's hair flat.

For a painting surface, Whitney uses an all-rag handmade paper, preferring Arches 140 lb. and 300 lb., both cold-pressed and rough. Additional materials include a small kitchen knife, plastic credit cards for linear effects, a sponge for picking up, tissues, hair-dryer, rubber cement, twigs, wax, pieces of wood and stones, and spittle. As he says: "Anything for desired effects: I'm a gadgeteer!"

If the subject is one that is better expressed by a soft treatment (such as fog, snow, surf, clouds), Whitney indicates details on a wet surface. If the subject is better expressed by hard contours (sunshine, urban scenes, rocks, and architectural details), he adds details after his large washes are completely dry.

Whitney finishes most of his watercolors in one hour (twenty minutes for some), with very little subsequent editing.

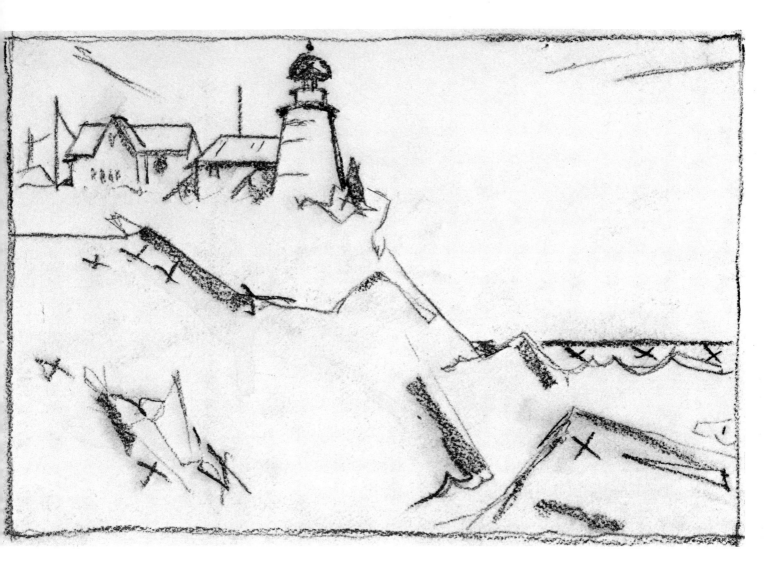

Step One: Whitney first visualizes his composition in a postcard-size sketch in which he allocates patterns of value. He refers to this small sketch as he draws in the major shapes on his watercolor sheet, using charcoal. Sea and rocks are indicated in oblique lines. As he draws, Whitney considers the principles of design and places the lights and darks in an interesting relationship throughout the sheet.

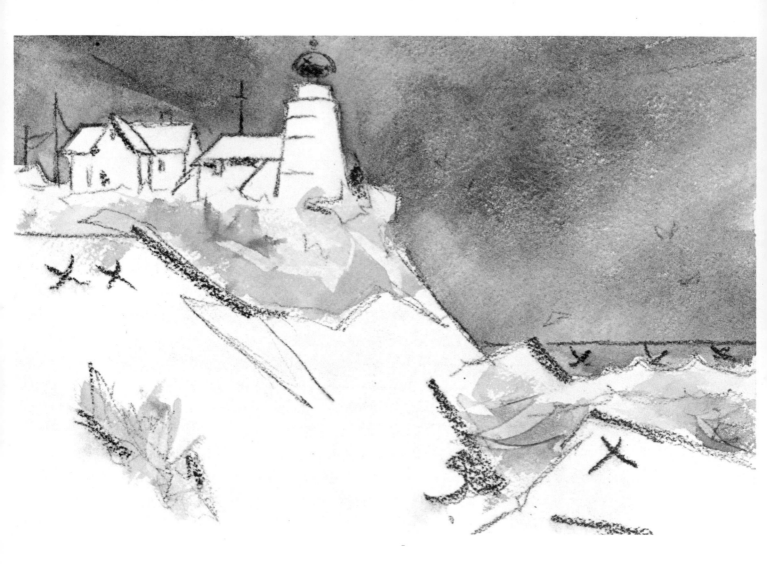

Step Two: Next Whitney paints in the light values. As he works on each area, he grades the application of color to avoid monotony. Using a large brush, he lays in the sky, then moves to the yellow and green foliage, and then to the surf. He works on a dry surface, applying his colors generously.

Step Three: Now Whitney adds the middle tones in the foreground rocks. This is a dominant area in the painting and must be handled with skill. In these large areas Whitney establishes what he calls "entertainment." At the same time he is careful not to make the rocks so "entertaining" that they detract from the painting as a whole.

Step Four: The dark values are applied now: the distant surf, the telephone poles, and details on the lighthouse. The whites are left untouched, yet Whitney works around the whites in such a way that their shapes form a vital function in the painting. He is particularly careful not to break up the large forms.

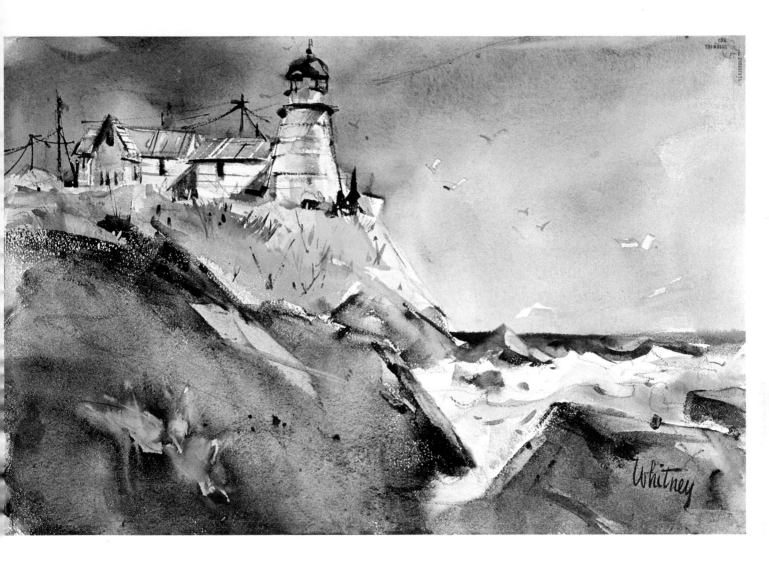

Step Five: Maine Coast, 15" x 22½". Now that the three values have been established, Whitney can focus on the details. He sharpens up the forms. By painting in strong cast shadows on the lighthouse and neighboring structures, Whitney provides the illusion of strong sunlight and gives interest to the white building. He lifts out the birds by blotting out the wet pigment and finally adds calligraphic details in the surf, shingles, and telegraph wires.

Alex F. Yaworski

Working generally in a low color key, Alex Yaworski is more concerned with the quality of the color used to obtain a somewhat abstracted interpretation of the subject than he is in rendering a detailed depiction of the image.

For his low color-key paintings, Yaworski relies on the following tube watercolors: cadmium yellow and orange, cadmium red, cadmium red deep, carmine, alizarin crimson, raw and burnt sienna, yellow ochre, raw and burnt umber, cerulean and cobalt blue, occasionally ultramarine blue, Hooker's green dark, viridian green, cobalt violet, Payne's gray, and ivory black. He also works in casein and acrylics, sometimes intermixing transparent watercolors with acrylics. In all these media his palette is generally the same: the number of colors may vary, but he prefers a large selection.

Yaworski's selection of brushes is also quite extensive: number 30 Winsor & Newton round sable, and two or three of the smaller sizes; a 1″ Grumbacher aquarelle and smaller flat-edged brushes. For soft areas of color he uses a 1½″ or 2″ housepainter's brush; for rough textures, an oil bristle brush; for casual line treatment, from a number 9 to a number 2 filbert. Sometimes he makes use of sponges and 2″ and 4″ sponge rubber rollers.

Yaworski is resourceful in his use of other materials as well. To retain the white areas of his paper he has used masking tape. More often, he has used masking liquid frisket for the same purpose. He has also used a razor blade for scratching out color and sponges for picking up color. He finds occasional use for salt, an aerosol power unit for spraying water, and a roller for the application of color. Acrylics come in handy as well: he may use them for part of his line drawing on the paper before applying watercolor. Because acrylics will not pick up or intermix with the watercolor, they can be seen for a longer period through the transparent color.

For painting on location—which he does frequently—Yaworski has devised a special easel: on an aluminum photographer's tripod he has attached a heavy-duty clipboard (with the clip placed at the bottom). By bending the clip he can string up the panning handle of the tripod through the hole in the clip, giving him a versatile tripod. Because the legs telescope, the unit is easily carried, and he can compensate for rough terrain by extending one leg more than another. The clipboard easily supports a full sheet of heavy watercolor paper stretched on Masonite, and he is able to alter the angle of his paper—from upright to horizontal—by turning the panning handle of the tripod.

In the studio Yaworski works at a regular commercial art table which can also be maneuvered into different angles, and he paints standing over the board. Because he can more easily plan his paintings with his tools readily available, his studio paintings are his best work, but only because he first gets a good deal of information outdoors. Since it is not difficult for him to drive to an area where he is to paint, and there is plenty of room in the car, he carries along, besides the easel, a bridge table, folding chair, and about three plastic gallon containers of water, and some small plastic bowls into which the water is poured when painting. He brings along other aids as well, such as a large butcher's tray for his palette, a power unit for spraying water on the paper, rollers, masking liquid frisket, salt, and some cold beer.

In the studio Yaworski either makes another version of his outdoor sketch or completes the painting started outdoors. For his preliminary color sketches, he sometimes uses a 14″ x 20″ 140 lb. rough Arches block, but more often full sheets of 300 lb. cold-pressed Arches or Fabriano paper which has been stretched on a piece of Masonite.

To plan his composition, Yaworski generally makes a small sketch (about 3″ x 5″) in black and white, in which he plans the lights and darks and to which he refers when composing his painting on the watercolor paper. Yaworski uses large brushes for masses of color. Rugged and casual effects are painted in with a bristle brush.

Step One: In this watercolor Yaworski interprets a casein sketch in which he had established the composition, color, and mood with opaque color from notes gathered from many on-location sketch trips. On a dry, stretched paper (300 lb. Arches cold-pressed paper which had been stretched on a piece of Masonite), Yaworski makes a pencil drawing to indicate where main areas of color changes will occur and which areas will receive Maskoid. (In the reproduction above, masked out areas are indicated in gray, about the value of the actual Maskoid.) In this particular picture, Yaworski intends to add subsequent drawing with a brush. Since his values in some areas will become quite dark, he does not want to add lines which will later become obscure in the painting process.

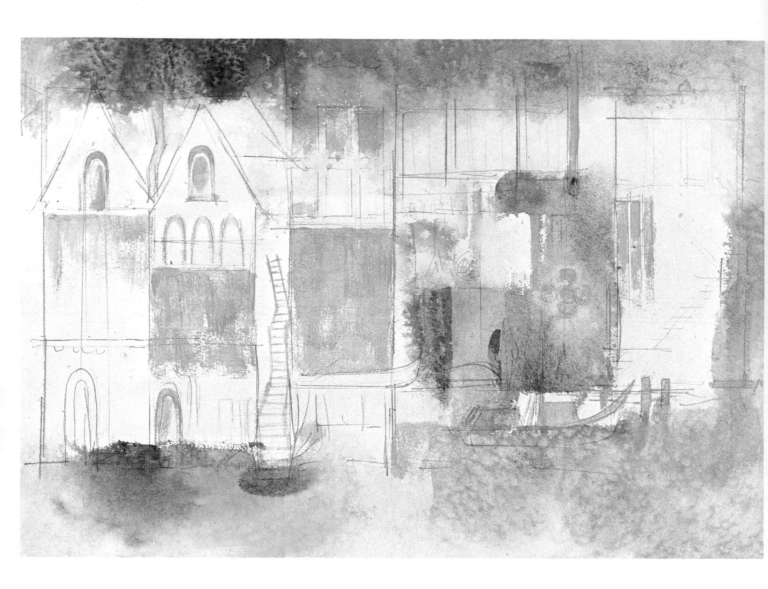

Step Two: Next Yaworski rewets the sky and foreground water with a large sable brush and washes in color. He starts with a light cool color in the upper left, adding green as he moves across the top of the sheet, and a warmer blue at the center point. From the center to the right he adds lighter values of blue, gray-green, and neutral tints. He continues these tints down the right of his composition and goes across the foreground areas of water in somewhat the same way as the sky, but in lighter values. At this point he sprinkles a little salt into the upper left and right corner areas and the lower right as well. He then adds some of the lighter and softer colors into the middle right section of the painting. After all this has dried, he brushes away the salt particles and adds the darker warm blue on the upper top left and the cooler and lighter blue on the center top, letting the color fade into the original neutral gray-green on the right. He uses a power pack to spray water where he wants to keep the blend soft. While all this is still wet, he adds more salt, then lets all the painting dry again before brushing the salt off the sheet. By permitting a light color to dry before applying another wash of the darker and warmer tone and then adding salt, the artist obtains an iridescent combination of warm and cool sparkles of color, the lighter color showing through where the salt "repelled" the wet new color.

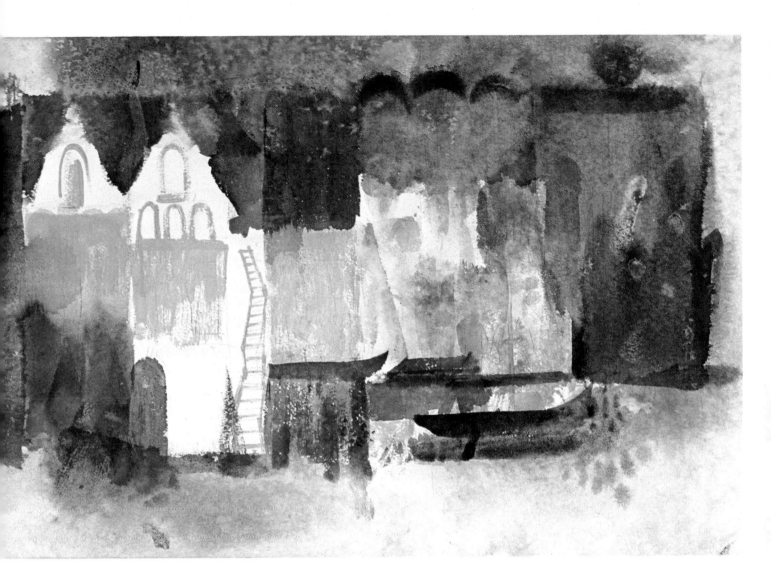

Step Three: Yaworski then applies the medium tones and variations of color on the buildings: the gray-greens on the roofs and on the structures at left; the ochres, browns, and grays on the right side of the building facades. Next he paints in the medium tones of the boat and the shadows in the water, some of which are added only after he sprays water over these areas again.

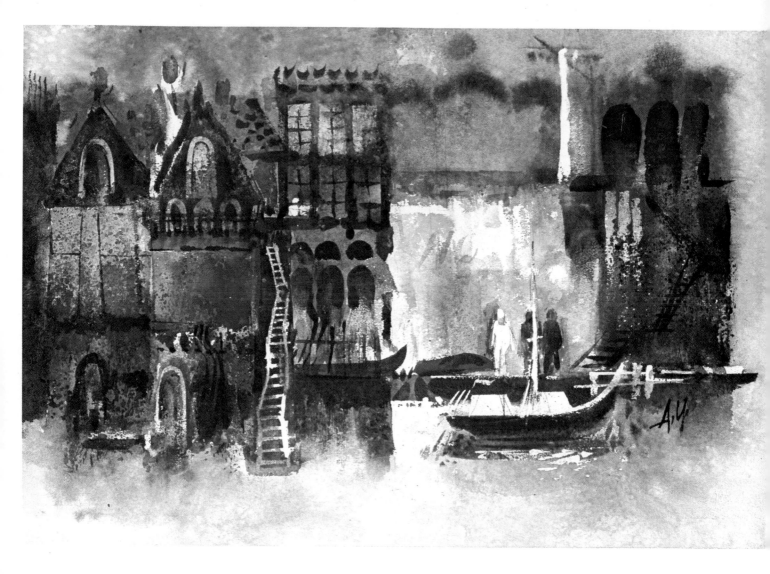

Step Four: After the sheet dries, Yaworski removes the Maskoid from the paper and adds color. He drops salt into these areas and applies paint with brushes and a sponge-rubber roller. To maintain a consistency in the painting, the windows— reflecting some of the texture in the sky and water—are treated with salt dropped into the color. By rolling cool color on warm (and vice versa) with the roller, Yaworski gives a texture to the building surfaces. He then adds the darks and the linear effects, bearing in mind the overall distribution of lights and darks, flat areas, and lost and found segments of detail. (Note: the left half of the painting now shows some of the dark accents and detail that will appear in the finished painting, while the right half still shows only the middle values. Here the white paper shows where Maskoid was removed and no color has yet been added.)

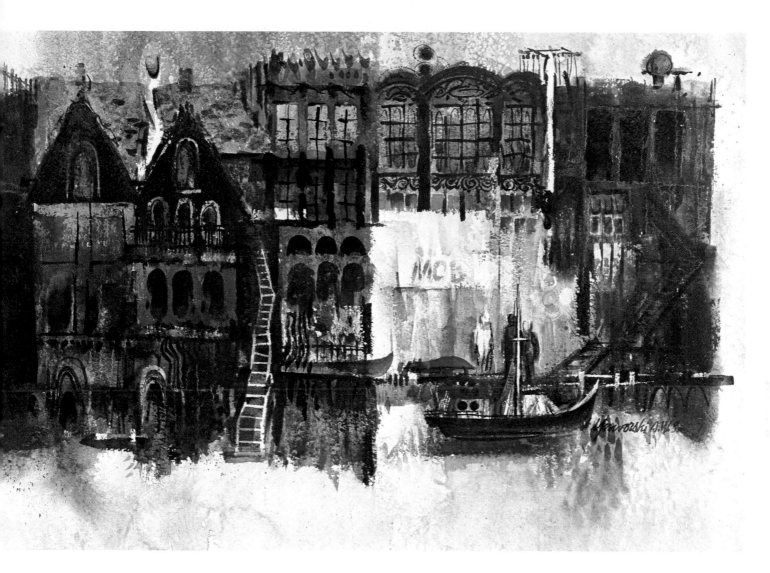

Step Five: Waterfront Facade No. 2, 19½″ x 28½″. Finally Yaworski completes the right half of the painting and sharpens up the details throughout, on a dry surface. Note particularly the work accomplished in the windows. To Yaworski, subject matter is secondary here. Above all he wants to create a strong semiabstract composition with a controlled vertical and horizontal pattern. He has followed his opaque sketch throughout.

Index

Edited by Adelia Rabine
Designed by James Craig
Composed in eleven point Vladimir by University Graphics, Inc.
Manufactured in Japan by Toppan Printing Co., Ltd.